DEDICATED TO
OKWUI ENWEZOR & BISI SILVA

MoAD ✳ Smithsonian *Affiliate*

COFFEE RHUM SUGAR & GOLD

A POSTCOLONIAL PARADOX

CURATED BY DEXTER WIMBERLY
AND LARRY OSSEI-MENSAH

CAMERON + COMPANY
Petaluma, California

CONTENTS

PAGE 1: Detail of Didier William, *"Lonbraj mwen se kouwon mwen"* 1, 2019

LEFT: Detail of Adler Guerrier, *Untitled (Place marked with an impulse, found to be held within the fold) iv*, 2019

DIRECTOR'S STATEMENT

JAMES LEVENTHAL
Acting Director & CEO

The Museum of the African Diaspora (MoAD) is thrilled to present the MoAD original exhibition *Coffee, Rhum, Sugar & Gold: A Postcolonial Paradox*, exploring the lingering effects of colonialism in the Caribbean through the work of ten artists connected to the region. MoAD is grateful for the vision of guest curators Larry Ossei-Mensah and Dexter Wimberly to bring together the work of ten incredible artists: Firelei Báez, Leonardo Benzant, Andrea Chung, Lavar Munroe, Angel Otero, Phillip Thomas, Lucia Hierro, Adler Guerrier, Ebony G. Patterson, and Didier William. The guest curators, the artists, and MoAD Director of Exhibitions and Curatorial Affairs Emily Kuhlmann have made something magical and timely. MoAD is especially grateful for the scholarly essay contributed by Professor Eddie Chambers from the Department of Art and Art History at the University of Texas at Austin.

Coffee, Rhum, Sugar & Gold: A Postcolonial Paradox looks at the legacy of European colonialism in the Caribbean through contemporary art. This could not be more timely as we collectively move through the tail end of the first quarter of the twenty-first century. When we projected ourselves forward into the twenty-first century from the last one, I think we saw an unencumbered future with new technologies that freed us from past sins. Instead, we now face administrations in the largest nations, including the United States and Brazil, embroiled in the issues of a colonial past. While there is very little actual coffee, rum, sugar, or gold in this exhibition, perhaps we are not truly in a postcolonial world. Even if certain empires are no more, hegemony and persecution persist. In the case of Puerto Rico, the United States is failing the island of enchantment through neglect that is well beyond benign.

At the same time, the term *decolonize* has become a significant catchphrase for the need for museums to better represent populations of color, to be inclusive, and to give voice to the disempowered through museum practice. MoAD, from its inception, has been dedicated to inclusion and the very idea that we all come from Africa. The museum, now only in its fourteenth year, is still young. Through original exhibitions such as *Coffee, Rhum, Sugar & Gold: A Postcolonial Paradox*; the related programs; and this very publication, the museum is able to assert its mission and reach a growing audience on-site and online, all with an understanding that museums are not neutral.

A year ago, I arrived at the Museum of the African Diaspora as deputy director and chief development officer. One of the first things that I worked on was the application to the Andy Warhol Foundation for the Visual Arts. The museum was successful, and the foundation's support has made all the difference. MoAD is so grateful to James Bewley, Rachel Bers, and the board of the foundation for their lead investment and encouragement.

The museum is equally grateful to the additional funders of this exhibition: Tad Freese and Brook Hartzell, Julie and David Levine, and MoAD Board Vice Chair Peggy Woodford Forbes. A timely grant from the Do A Little Foundation also made this all seem possible.

Lead funding for MoAD is provided by Dignity Health. With thanks to the leadership of MoAD Board Chair L. Wade Rose, Dignity Health and its two CEOs, Lloyd Dean and Kevin Lofton, made an extraordinary gift to create a Cultural Education and Artist Development Fund at MoAD. Thanks to that gift, the museum has been able to navigate this time of transition, with an eye on recruiting its next director.

It is important to note that a large portion of the museum's programmatic and operational needs are funded through the Afropolitan Ball. Last year's honorees were Dr. Elizabeth Alexander, president of the Andrew W. Mellon Foundation, and Karen Jenkins-Johnson, founder and director of the Jenkins Johnson Gallery. The event cochairs were board member Eric Reed and community leader Monetta White. Together they helped raise more than $1.3 million for the museum's mission from major supporters of the Afropolitan Ball, including Jill Cowan Davis and Stephen Davis, Concepción and Irwin Federman, Karen Jenkins-Johnson and Kevin D. Johnson, Beryl and James Potter, Jordan Schnitzer Family Foundation, the Allen Group LLC, FivePoint, Gilead, Verizon, Pacific Gas and Electric Company, Target, Union Bank, and Wells Fargo.

Generous support for programs and exhibitions at MoAD is also provided by Kaiser Permanente and the Yerba Buena Community Benefit District. The City of San Francisco is the primary funder, and it is thanks to Mayor London Breed and City Administrator Naomi Kelly that MoAD is able to keep up its essential work.

Across the years, MoAD has made possible important programming thanks to the board's dedication and generosity and because of a small, capable, collaborative, and seemingly tireless staff team. Emily Kuhlmann, as director of exhibitions and curatorial affairs, leads up the exhibitions from conception to closing with something of a Midas touch, all while overseeing every installation—from gallery mapping diagrams down to touch-up paint. Working closely with Emily, Elena Gross is a welcome and cherished new member of the curatorial department. Mark Sabb is the museum's Senior Director of Innovation and Engagement, and his vision for the in-gallery augmented-reality interactives for this exhibition will ripple across the museum field as a model. Together with Senior Director of Education Demetri Broxton, what they are doing in the museum's recently minted Art Studio, too, will be pacesetting. Richard Collins runs the Will to Adorn and other school programs, which have continued to grow by 20 percent each year.

I am thrilled by all the programming in the works, with thanks to the brilliant Director of Public Programs Elizabeth Gessel, PhD. Linda Spain de Bruin, thank you for keeping all the finances in order, along with Chris Jaffe, Sylvia Lin, and Lawrence Villegas. On the development team, thank you, Azha Simmons and Nicole Winthrop. Suzy Drell, your events management skills are invaluable to the museum's success. On the operations side, Janan Sirhan and Rahel Smith help keep the facilities and HR covered, respectively. Kitsaun King is the backbone of membership and so much more, and she helps keep the Afropolitan Ball going at the necessary, fast clip needed to make the goal each year. Paul Plale, as lead designer, has the touch and makes everything look great—from oversized vinyl wraps to invitations. Nia McAllister, you are such a key leader and the always-warm welcome for the museum, along with Naomi Neal. Thanks, too, to other interns and volunteers who enliven the museum through their dedication and hard work, including Hyunji Jeong, Somin Lee, Josh Sanders, and so many more.

Detail of Phillip Thomas, *Pimper's paradise, the Terra Nova nights edition*, 2018

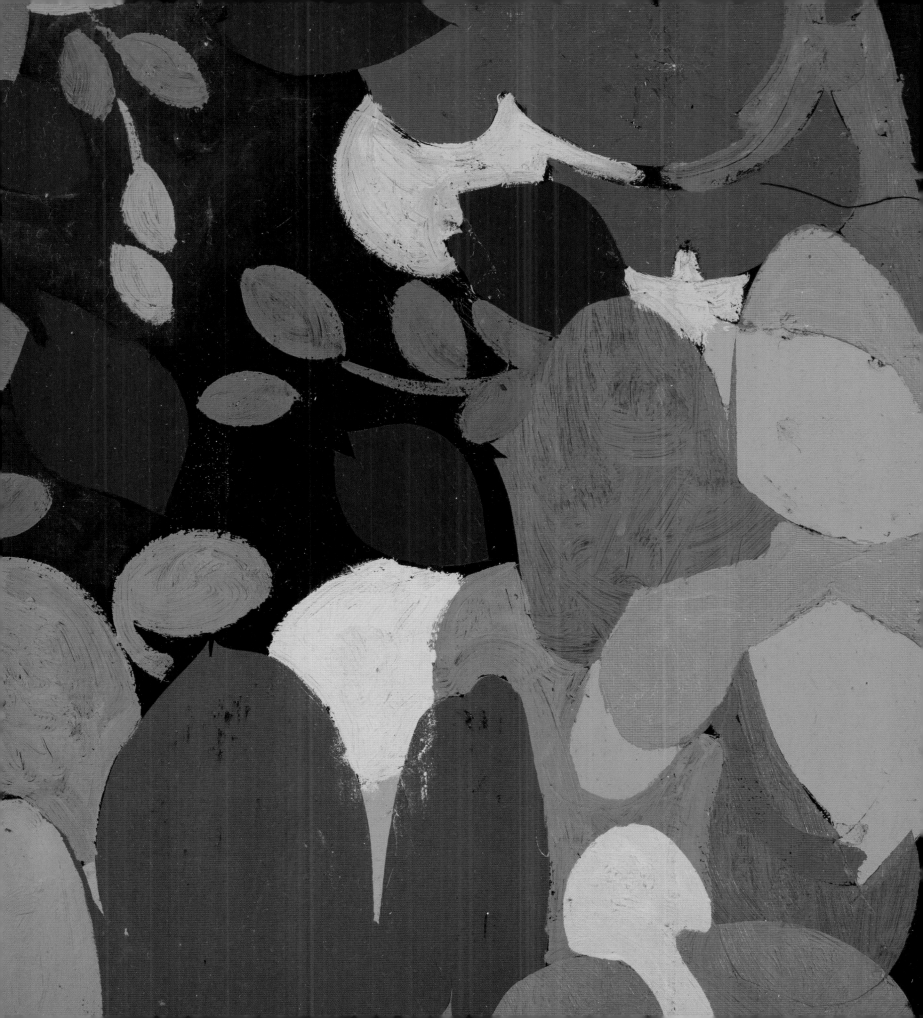

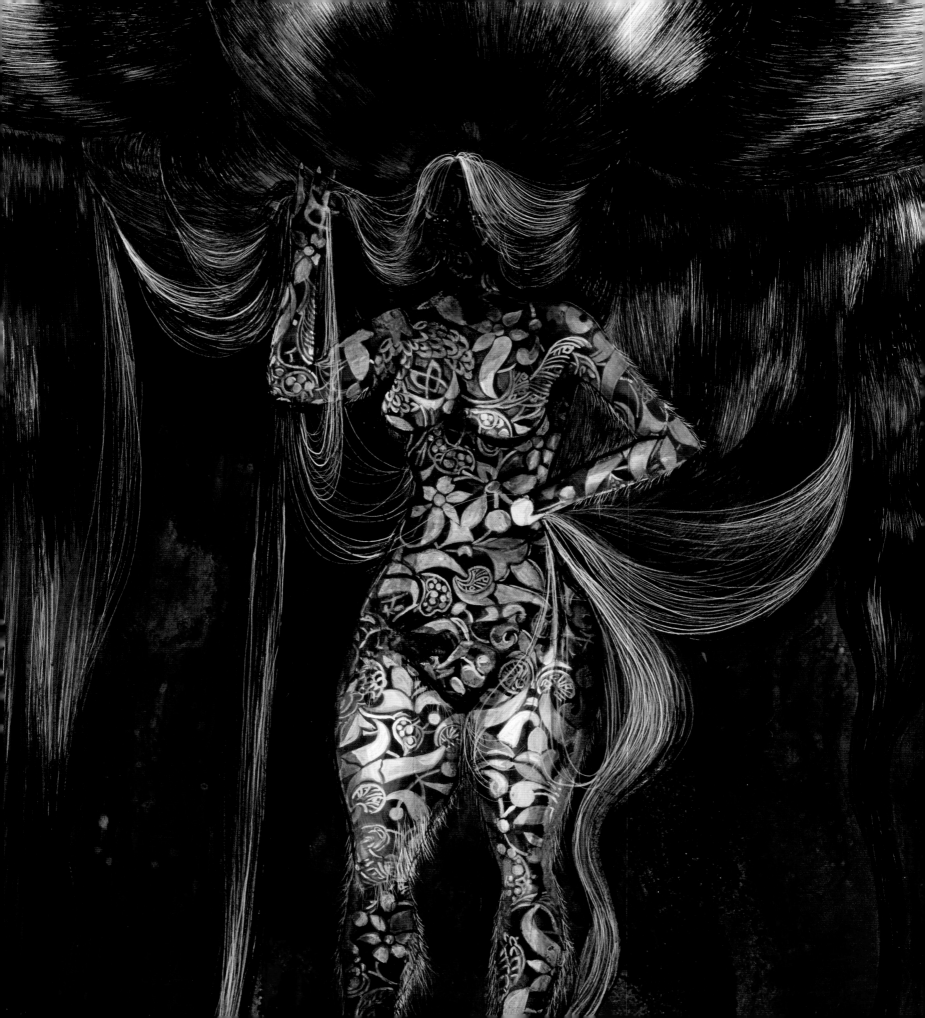

LARRY OSSEI-MENSAH

Susanne Feld Hilberry
Senior Curator

Museum of Contemporary Art,
Detroit

Cofounder of ARTNOIR

A civilization that proves incapable of solving the problems it creates is a decadent civilization.

A civilization that chooses to close its eyes to its most crucial problems is a stricken civilization.

A civilization that uses its principles for trickery and deceit is a dying civilization.

—Aimé Césaire[1]

Coffee, Rhum, Sugar & Gold: A Postcolonial Paradox is the continuation of an ongoing inquiry that has informed my curatorial practice for the past several years, as I work to examine the fruits borne as a result of European colonialism and empire-building and its effects on contemporary society. Western development and wealth have been built on the backs of the disenfranchised, specifically those from the global south. European exploitation and extraction have caused ripple effects that have shaped public policy, the construct of identity, and power structures in these colonized spaces for centuries.

Many history books and politicians falsely lead us to believe that there was a definitive fall of the empires that established these frameworks through oppression, suppression, and barbarism for the sake of power and supremacy, and that colonialism and imperialism ended then. Many may think that these acts by the British, Portuguese, Spanish, and French empires are a thing of the (very recent) past. However, the effects of a long history of European consumption and abuse, as well as the relatively more recent growth and impact of the American empire, are clearly present in the twenty-first century. The legacies of colonialism and imperialism take a multitude of forms, such as the British Commonwealth; France's demand that Haiti pay the country for the loss of slaves after the Haitian Revolution, equivalent to $21 billion today (this debt took 122 years for the island to pay); the breeze-block architecture that has shaped the architecture of many Caribbean islands; and white nationalist ideologies that work to oppose and alienate minority populations. All of these variables have come to shape what we deem a postcolonial paradox—it is the fruit grown from the seeds that European and American empires have sown.

Detail of Firelei Báez,
Compulsion to remember and repeat, 2016

For the purpose of this exhibition, my cocurator Dexter Wimberly and I decided early that utilizing the lens of the Caribbean as a framework to engage in this discourse was essential, given that the core goods historically produced in and exported from the Caribbean to the rest of the world have never truly benefited the individuals who have toiled, suffered, and sacrificed for their own sovereignty and liberation. Moreover, taking into account the region's proximity to the United States brings to bear a plethora of other concerns. The shift from colonial rule to the emergence of imperialist tactics yields a different kind of ripple effect and tension when you take into consideration America's involvement in the region—Puerto Rico as a territory, and interventions in the Dominican Republic, Haiti, and Cuba, for example. Furthermore, one of the main drivers is that all of these variables are connected and interrelated. It might be a beast called by a different name, but the by-product is of the same making. It is imperative to investigate colonialism's economic, physical, mental, and psychological influence beyond the obvious with the commodities that ground the exhibition. It is through this exploration, unpacking, and decoding, with art as our translator that our society is able to wrap its head around the policies and behaviors that have shaped our contemporary world. By peeling the layers of the seeds sown in the past, the present moment comes into clearer view, and it creates a potential pathway for an equitable future.

> "What am I driving at? At this idea: that no one colonizes innocently, that no one colonizes with impunity either; that a nation which colonizes, that a civilization which justifies colonization—and therefore force—is already a sick civilization, a civilization that is morally diseased. . . ."
>
> —Aimé Césaire[2]

The shaping of identity for many who live in these spaces, or are descendants of individuals from these spaces, adds another nuanced layer to this deeply complicated discourse. More than three million people with Caribbean heritage live in the United States. The effects of colonialism still have a hold on the psyche of individuals of Caribbean descent, as well as on the policies that impact them. Moreover, ideologies of exploitation and extraction have seeped into the consciousness of the United States and other world superpowers that continue to benefit from the by-products of the labor, blood,

Detail of Andrea Chung, *Proverbs 12:22*, 2019

sweat, and tears of these disenfranchised communities across the Caribbean, African diaspora, and Global South.

The aim of this exhibition is to look at the Caribbean as a whole rather than parsing it into bits and pieces demarcated by colonial lines or those constructed by manufactured borders, languages, or locations within the region. Furthermore, the exhibition seeks to examine power structures (economic, policy, etc.) and particularly their direct and indirect impact on the Caribbean and individuals who reside there. Additionally, the exhibition seeks to ask a series of questions: What is the role of cultural resistance via the lens of music, food, carnival, and spiritual practice? How do the forms

Detail of Angel Otero,
Untitled, 2013

of expression birth a new cultural context? As a result of this postcolonial paradox, who benefits from these power structures that have been put in place, and who actively is seeking to liberate themselves from the echo effects of this trauma? The liberation that I speak of is not just physical, but also mental: What are the steps one must take to decolonize the mind? Moreover, *Coffee, Rhum, Sugar & Gold* enables not only an examination of the challenges of the postcolonial paradox, but also exposes audiences to the varied ways these power structures operate, bear fruit, and multiply. Furthermore, how does this proliferation of certain ideas and ideologies have generational effects for years to come?

[1] Aimé Césaire, *Discourse on Colonialism*, trans. Joan Pinkham (Monthly Review Press; NYU Press, 2000) 29–78, www.jstor.org/stable/j.ctt9qfkrm.4.

[2] Ibid.

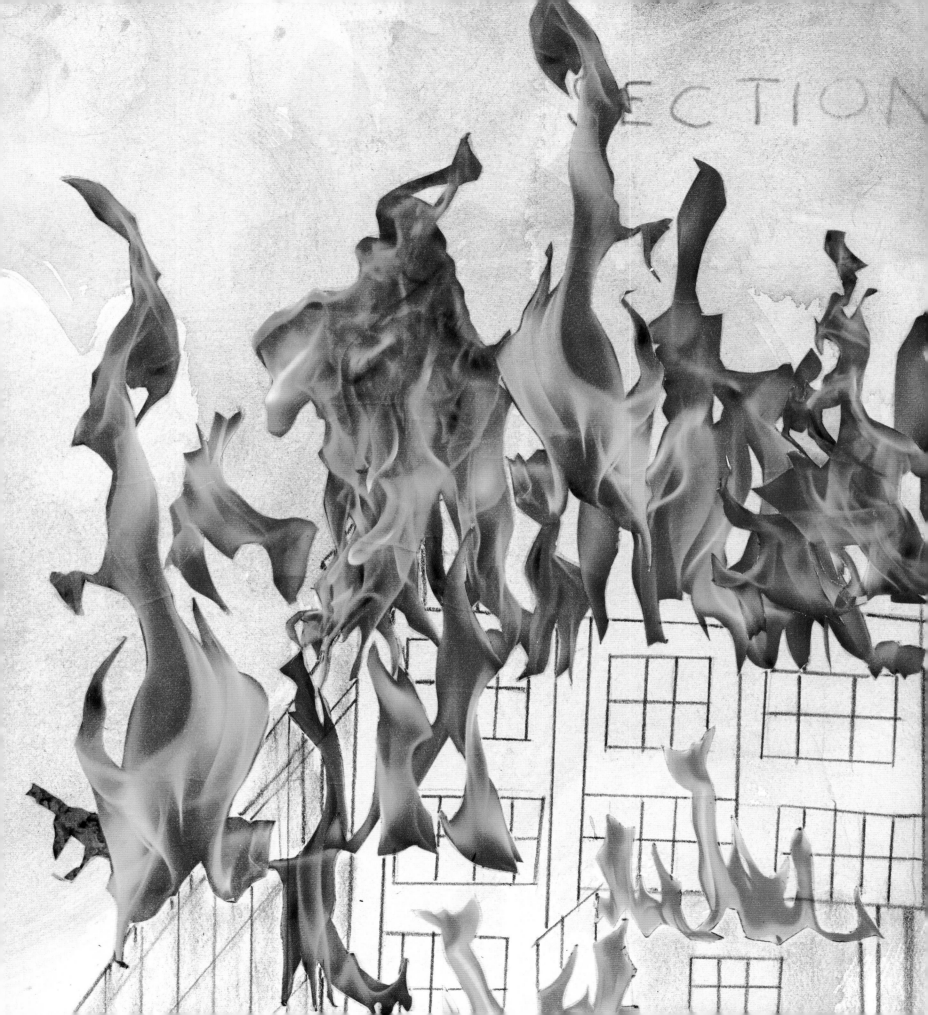

DEXTER WIMBERLY

Founder and CEO

Art World Conference, LLC

Independent Curator

C offee, Rhum, Sugar & Gold: A Postcolonial Paradox is an exhibition that looks at the legacy of European colonialism in the Caribbean and beyond, through the work of ten contemporary artists. Whether connected to the Caribbean by birth or focused on the region by choice, the exhibiting artists use their work as a means of examining the relationship between the power structure, those who are controlled by it, those who benefit from it, and those who actively seek to liberate themselves from it.

To quote University of Leeds professor John McLeod in his 2000 book, *Beginning Postcolonialism*, "Indeed, we might consider that colonial discourses have been successful because they are so productive: they enable some colonizers to feel important, superior, noble, and benign, as well as gaining the complicity of the colonized by enabling some people to derive a sense of self-worth and material benefit through their participation in the business of Empire."[1]

We refer to the word *paradox* because, in some cases, the contemporary beneficiaries of colonialism's legacy are also people of color who, by choice or accident, perpetuate the cycle of economic subjugation and oppression initiated by European colonizers. This exhibition's title is also inspired by some of the core products that have historically been produced in and exported from the Caribbean to the rest of the world. A key driver of the exhibition is the theory that colonialism has continued to exist in other forms, and is in fact spreading through the export of soft power, the use of military force, and the control of international financial and banking mechanisms, as well as the increase in globalization.

Most of the thousands of studies on the topic of colonialism find that, while colonial rule brought some improvements in economic growth and long-term health and well-being, many of the postcolonial world's economic and political difficulties (including corruption, poor economic productivity, and violence) are directly linked to colonialism and the geopolitical system it created.[2] Here, I explore some of that history, as well as its lasting impact.

One hundred fifty years after Britain abolished slavery, it seems appropriate to evaluate the impact of colonialism on the Caribbean islands and the circum-Caribbean mainland. From discovery onward, the influence of Europe was profound. Amerindian populations were largely destroyed by colonial

Detail of Firelei Báez, *Love that does not choose you (Collapse the rooms and structures that depend on you to hold them)*, 2018

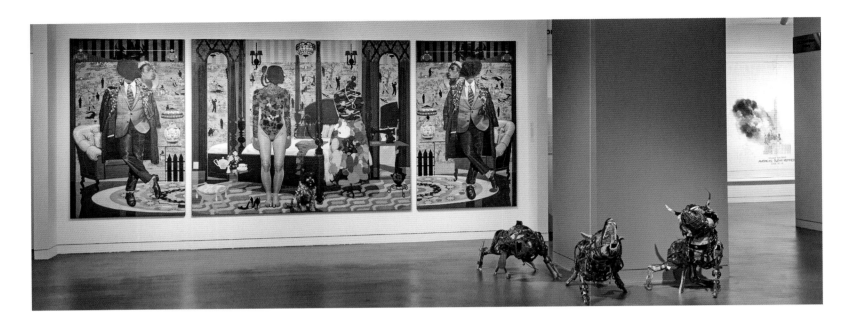

contact and exploitation; pre-Columbian economies were eliminated or marginalized by mercantilism, principally in the form of the sugar plantation; and the social order was reconstructed according to the colonists' views of the natural order of racial stratification, based upon white superiority and black slavery.[3]

Colonialism is defined by Merriam-Webster as "control by one power over a dependent area or people." It occurs when one nation subjugates another, conquering and exploiting its population, often while forcing its own language and cultural values upon its people. By 1914, a large majority of the world's nations had been colonized by Europeans at some point. The concept of colonialism is closely linked to that of imperialism; that is, the policy or ethos of using power and influence to control another nation or people, which underlies colonialism.

Modern colonialism began during what's also known as the age of discovery. Starting in the fifteenth century, Portugal began looking for new trade routes and searching for civilizations outside Europe. In 1415, Portuguese explorers conquered Ceuta, a coastal town in North Africa, kicking off an empire that lasted until 1999. In 1492, Christopher Columbus began looking for a western route to India and China. Instead, he landed in the Bahamas, kicking off the Spanish empire. Spain and Portugal became locked in competition for new territories and took over indigenous lands in the Americas, India, Africa, and Asia.

England, the Netherlands, France, and Germany quickly commenced their own empire-building overseas, fighting Spain and Portugal for the right to lands they had already conquered. Despite the growth of European colonies

ABOVE & RIGHT: Installation images, MoAD, 2019

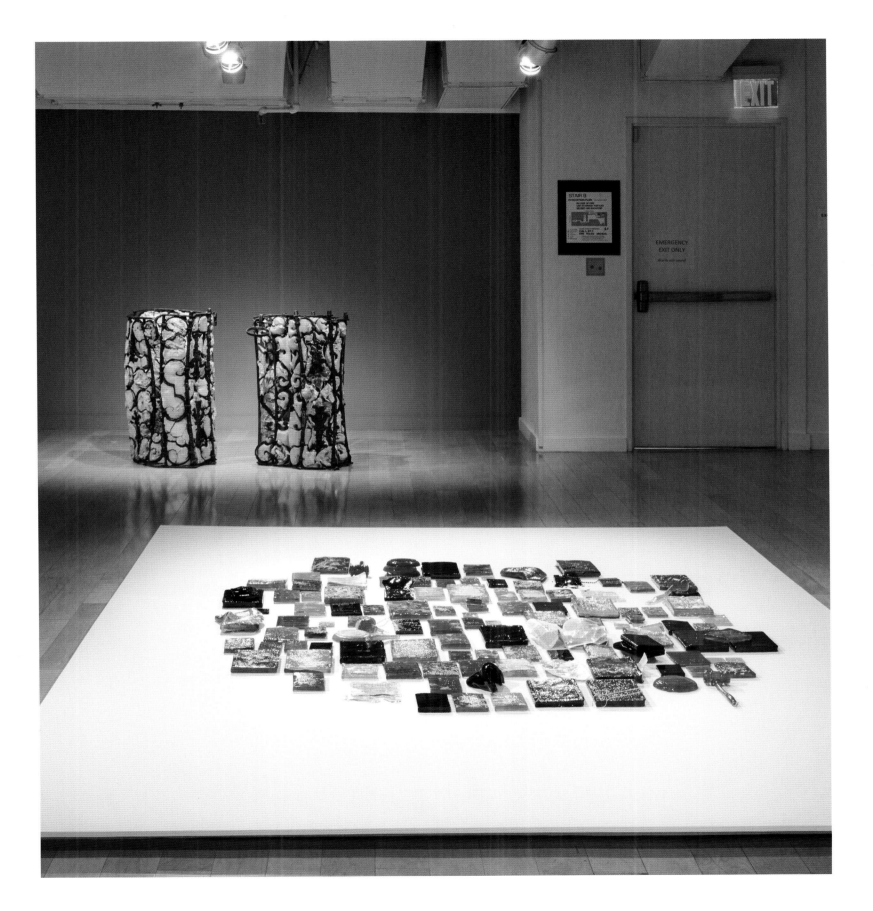

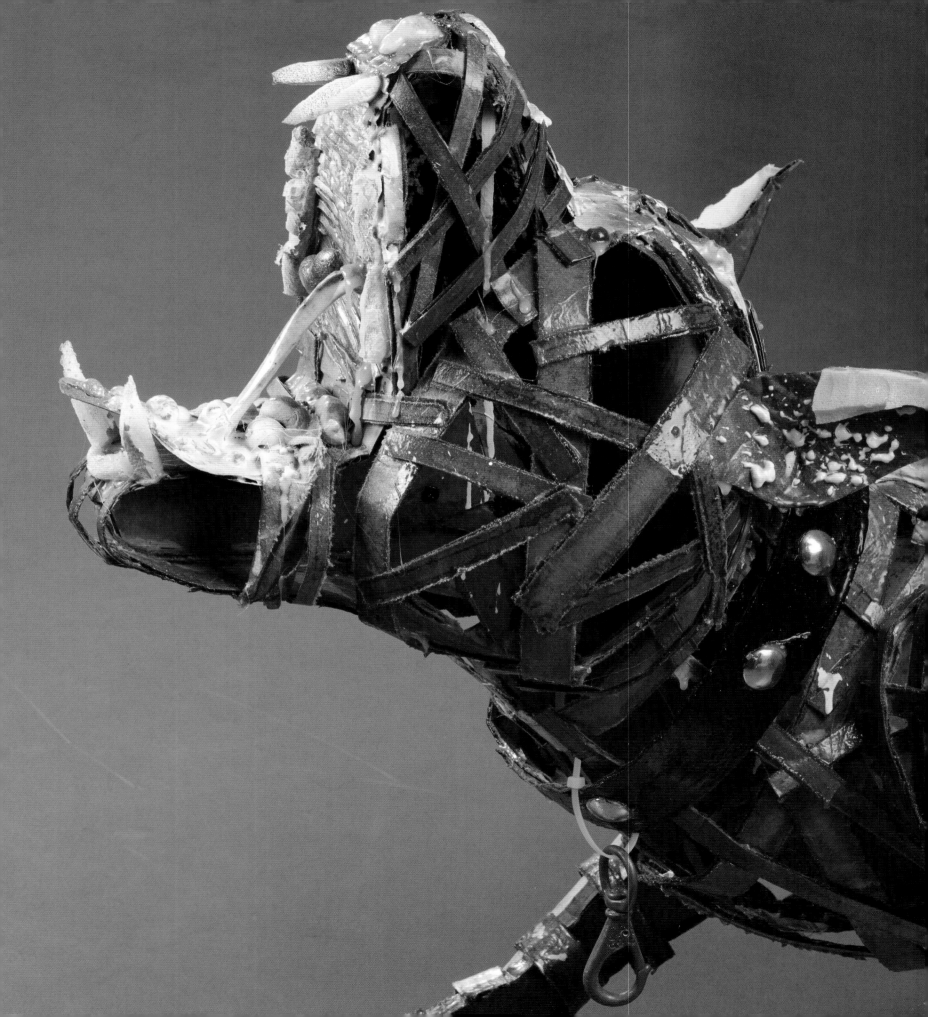

in the New World, most countries managed to gain independence during the eighteenth and nineteenth centuries, beginning with the American Revolution in 1776 and the Haitian Revolution in 1791. However, the Eastern hemisphere continued to tempt European colonial powers. Starting in the 1880s, European nations focused on taking over African lands, racing one another to coveted natural resources and establishing colonies they held until an international period of decolonization began around 1914, challenging European colonial empires up to 1975.

Colonial powers justified their conquests by asserting that they had a legal and religious obligation to take over the land and culture of indigenous peoples. Conquering nations cast their role as civilizing "barbaric" or "savage" nations, and argued that they were acting in the best interests of those whose lands and peoples they exploited.

Despite the power of colonizers who claimed lands that were already owned and populated by indigenous peoples, resistance is an integral part of the story of colonialism. Even before decolonization, indigenous people on all continents staged violent and nonviolent resistance to their conquerors.[4]

The expansion of European overseas empires starting at the end of the fifteenth century caused major changes in the organization of many of these societies. In fact, historical and econometric evidence suggests that European colonialism caused an "institutional reversal": European colonialism led to the development of institutions of private property in previously poor areas, while introducing extractive institutions and taxes, or maintaining existing extractive institutions, in previously prosperous places.

What is important is not the "plunder" or the direct depredation of resources by the European powers, but the long-term consequences of the institutions that they set up to support extraction. The distinguishing feature of these institutions was a high concentration of political power in the hands of a few who extracted resources from the rest of the population. For example, the main objective of the Spanish and Portuguese colonization was to obtain silver, gold, and other valuables from America, and throughout, they monopolized military power to enable the extraction of these resources. The mining network set up for this reason was based on forced labor and the oppression of the native population. Similarly, the British West Indies in the seventeenth and eighteenth centuries were controlled by a small group of planters. Political power was important to the planters in the West Indies, and to other elites in the colonies specializing in plantation agriculture, because it enabled them to force large masses of natives or enslaved Africans to work for low wages.[5]

Scholars point out, for example, that the goals of seventeenth-century Spanish colonialism were different from those of the British in the late

Detail of Lavar Munroe, *And the Dogs Went Silent: Gun Dog 3*, 2017

nineteenth century. This meant colonizers chose to colonize different places and adopt different governing strategies. But while some studies find that former British colonies have performed better economically and politically than others, virtually none find that colonial rule was itself an effective method of setting up long-term prosperity and stability.

It's true that colonial governments invested in public services and infrastructure such as hospitals, railroads, roads, and schools. But careful scholarship shows that these investments did colonies little good. In his brilliant 1994 book, *The African Colonial State in Comparative Perspective*,[6] political scientist Crawford Young systematically tracks African colonial taxation and expenditures. He finds that tax burdens on small farmers, workers, and other colonial subjects far exceeded any reciprocal investments in public goods, while the bulk of the money was allocated toward maintaining the colonial government. In parts of West Africa, the tax burdens on farmers were so high in the 1930s that they created a cycle of poverty and debt that keeps their descendants poor today.[7]

Detail of Adler Guerrier, *Untitled (Presence in this place is contingent on forms; Sugarcane) I*, 2019

[1] John McLeod, *Beginning Postcolonialism* (Manchester, UK: Manchester University Press, 2000).

[2] Brandon Kendhammer, "A controversial article praises colonialism. But colonialism's real legacy was ugly," *Washington Post*, September 19, 2017, https://www.washingtonpost.com/news/monkey-cage/wp/2017/09/19/colonialism-left-behind-a-long-legacy-most-of-it-bad/?utm_term=.57db0bea3a74.

[3] Colin Clarke, "Colonialism and Its Social and Cultural Consequences in the Caribbean," *Journal of Latin American Studies*, 15, no. 2 (Cambridge, UK: Cambridge University Press, November 1983).

[4] Erin Blakemore, "What is colonialism? The history of colonialism is one of brutal subjugation of indigenous peoples," *National Geographic*, February 19, 2019, https://www.nationalgeographic.com/culture/topics/reference/colonialism/.

[5] Daron Acemoglu, Simon Johnson, James A. Robinson, "Reversal of Fortune: Geography and Institutions in the Making of the Modern World Income Distribution," *Quarterly Journal of Economics*, 117, no. 4 (November 2002).

[6] Crawford Young, *The African Colonial State in Comparative Perspective* (New Haven, Connecticut: Yale University Press, 2007).

[7] Brandon Kendhammer, "A controversial article praises colonialism. But colonialism's real legacy was ugly," *Washington Post*, September 19, 2017, https://www.washingtonpost.com/news/monkey-cage/wp/2017/09/19/colonialism-left-behind-a-long-legacy-most-of-it-bad/?utm_term=.57db0bea3a74.

EMILY A. KUHLMANN

Director of Exhibitions and
Curatorial Affairs

Museum of the African
Diaspora, San Francisco

An aesthetic legacy of imperialism is often seen in architectural structures that remain in colonized countries. Columns and coffered ceilings are the visual traces of European presence in the Caribbean. Within the Georgian government buildings in Nassau, the Bahamian House of Parliament does not escape purporting the architectural motifs of colonial rule. Even the Government House, the official residence of the governor-general, the representative of the Bahamian monarch (currently Queen Elizabeth II), stands with ionic columns and a statue of Christopher Columbus, which greet each visitor. The governor-general serves his or her term at Her Majesty's pleasure in the Commonwealth.[1] The colonial presence in the Caribbean, then, is not only foundational in physical structure but also insidiously archived in the articulations of governmental and economic systems.

Coffee, Rhum, Sugar & Gold: A Postcolonial Paradox provides moments of illumination of the often invisible structures initiated by colonialism. The transatlantic slave trade in the Caribbean informs current experiences and diasporic memories of this specific geopolitical constellation. With this understood, many of the works in this exhibition function as modes of analysis, engagement, and critical creation. Thinking through the work of Firelei Báez, Angel Otero, and Lucia Hierro, each artist engages various strategies in connecting with the colonial legacy of their homelands. The deep familial ties that these artists have to countries in the Caribbean, and their personal experiences living and working on the islands, situate the cultural economics as tethers to their work.

Memories, both cultural and individual, of structural oppression as expressed through trade and material capital of the region can immediately be read in the work of Firelei Báez. Interested in the *inherited* story, this Dominican-American artist takes seriously in her work ways in which the exploitation of the land and natural composition of the Dominican Republic replicates, extrapolates, and mechanizes oppressive practices in labor. *How to slip out of your body quietly* (2018), a work on paper, suggests the relationship between the human body and the land as kinetic, furred legs supporting windblown palms. While the palms serve utilitarian functions for the island economically, in supporting agricultural interests, domestic construction, and food products, they also act as a cultural touchstone and national symbol.[2] This work, in

Detail of Lavar Munroe,
Church in the Wild, 2019

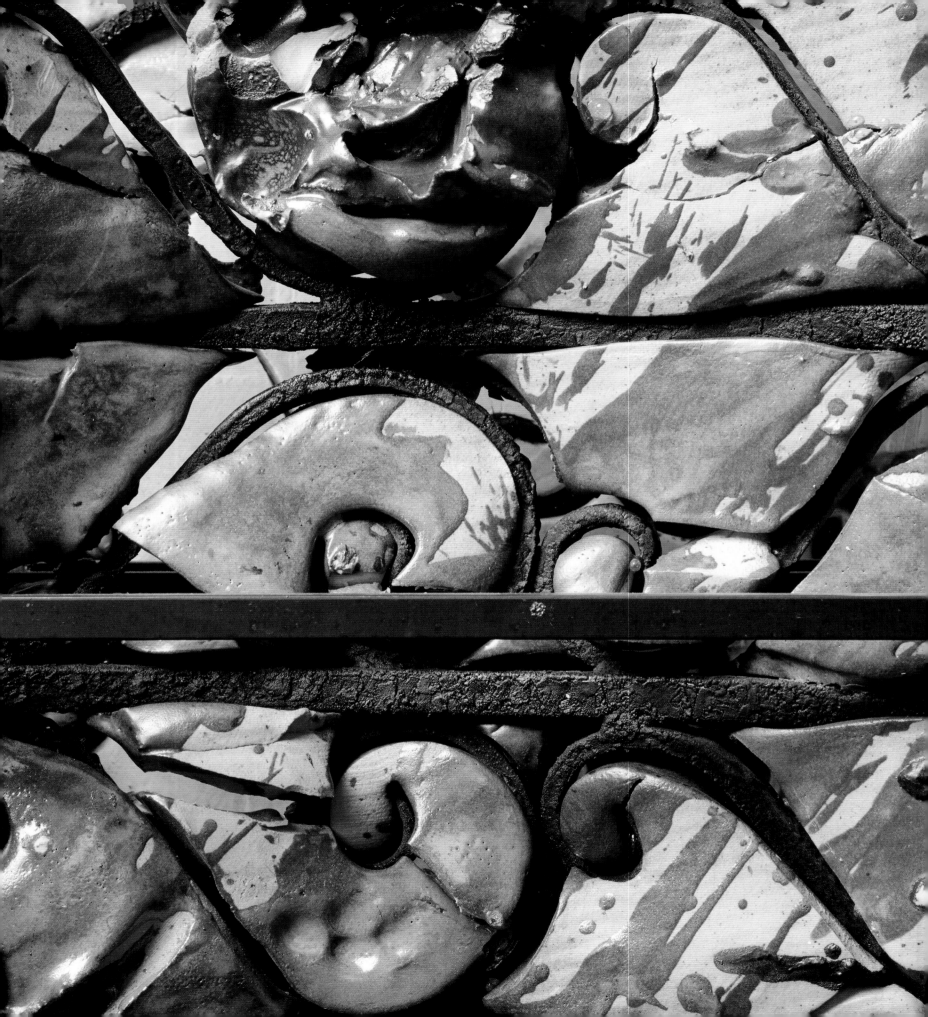

a pairing with *Love that does not choose you (Collapse the rooms and structures that depend on you to hold them)* (2018), emphasizes the human in the relation to the land. The export of sugar is characterized by the once-largest refinery in the United States, the Domino Sugar Refinery, on the Brooklyn skyline. In presenting the burning building with the schematics of the architectural designs, Báez conveys that the reference to the destruction of the systematic planning instructions could mirror the ultimate desire of destroying infrastructure for economic exploitation, labor coercion, and domestic labor disputes.[3] In rendering this significant building, the collective cultural memories of both New York and the Dominican Republic intersect in the lines of the plans.

In the exploration of the legacy of economic exploitation, the effects might not be as evident or calculating in our everyday life. Even in the simple presence of a gate, steel in material and yet aesthetically decorated, the functional use is not only to protect but to make sure that there is a division. In combining luxury-aligned porcelain with steel formations, Puerto Rican–born Angel Otero asserts a juxtaposition of associations. The luxury pertaining to colonial porcelain figurines and European dinnerware cannot be extracted from the material even as it is protected by the ornate steel gating that surrounds Otero's sculptural work. As the two objects stand on the gallery floor, the steel constricts the glazed porcelain seemingly in a gesture of protection. The porcelain almost swallows the curves of the designed steel, as a fleur-de-lis demarcates the various European colonial impacts on the Caribbean. Viewed from between the steel bars, denoting colonial influence, the porcelain remains separate from the environment. In its tight formation within the bars, *Veranda (Sca02)* (2013) reminds us that the colonial legacy is about the amassing and sequestering of resources instead of the dispersal of capital.

The intertwined nature of capital and the influence on consumption is visually displayed in Lucia Hierro's installations. The economic trade of materials, one of the ways in which diaspora maintains connections, inherently links one to the aromas and flavors of a homeland. Hierro, who has roots in the Dominican Republic, explores the cultural context of products. *Embajador* (2017), part of her *Mercado* series, stages hyper-exaggerated-size boxes of melting chocolate, imported from the Dominican, forming the oversized soft sculpture.

Detail of Angel Otero, *"Slots" Sl#1 (SCA03)*, 2013

LEFT: Detail of Ebony G. Patterson, *A View Out*, 2015

RIGHT: Detail of Lucia Hierro, *Aesthetics y Politics*, 2019

[1] Dame Marguerite Pindling is the current governor-general of the Commonwealth of the Bahamas (2019).

[2] Oscar H. Horst, "The Utility of Palms in the Cultural Landscape of the Dominican Republic," *Principes* 41, no. 1, (January 1997).

[3] Leigh Raiford and Robin J. Hayes, "Remembering the Workers of the Domino Sugar Factory," *The Atlantic*, July 3, 2014, www.theatlantic.com/business/archive/2014/07/remembering-the-workers-of-the-domino-sugar-factory/373930/.

"Chocolate de mesa," the slogan printed on the box, relates this product to the kitchen table and potential memories of a homeland. Echoes of Andy Warhol's *Brillo Boxes* (1964) resonate with Hierro's work in form and in the exploration of consumerism, as the boxes of chocolate spill out of the bag and are strewn on the floor. It is often only through consumption of products that people are able to connect with their cultural roots while living in the United States. The Spanish *embajado* translates to "ambassador," and this work poetically posits that, through consumerism and capitalism, these products function as official representative diplomats.

Pervasive colonial wealth accumulation through oppressive structures of forced free labor and material resource extraction underpins the cultural formation of the Caribbean as a geopolitical site. Báez, Otero, and Hierro, along with the other artists in this exhibition, show us ways of exploring, exposing, and fundamentally engaging with the colonial past that shapes our contemporary experience. Many of the artists in this exhibition currently live and work in the United States, and familial and ancestral ties connect them to the Caribbean countries. The economic structures of imperialism shadow cultural production in many forms as artists grapple with the permanent imprint of colonialism on Caribbean nations and the United States, suggesting, in part, that we might look at where white columns are built within the United States.

PLATES

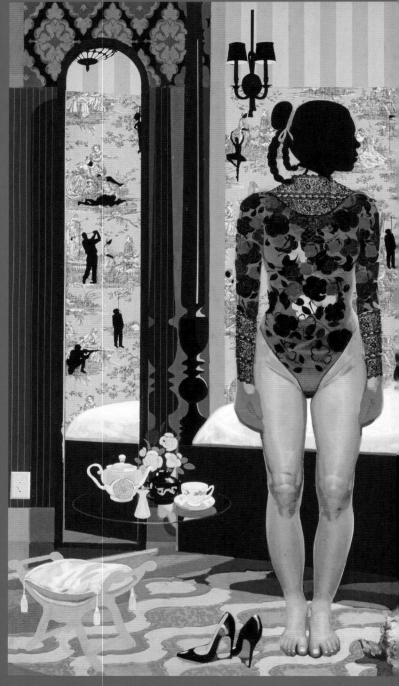

Phillip Thomas, *Pimper's paradise, the Terra Nova nights edition*, 2018

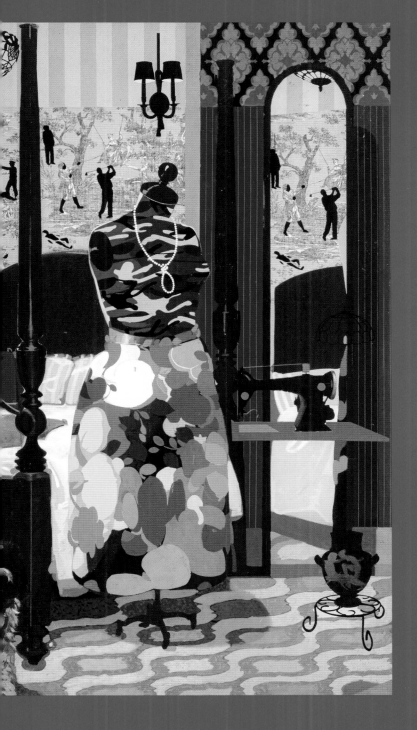
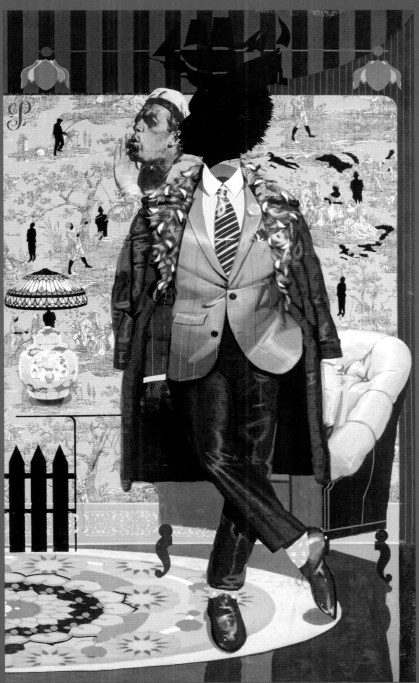

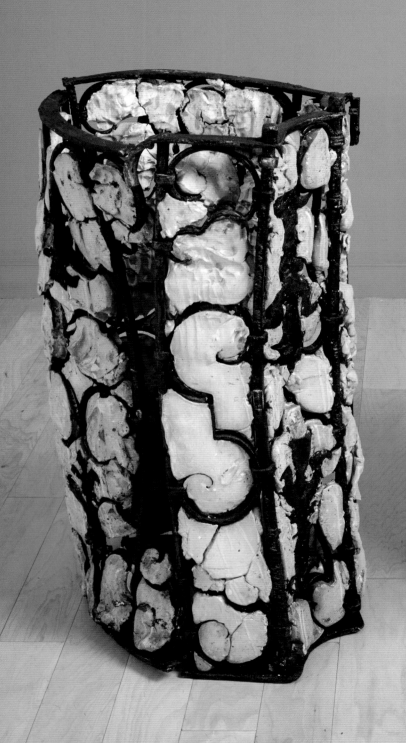
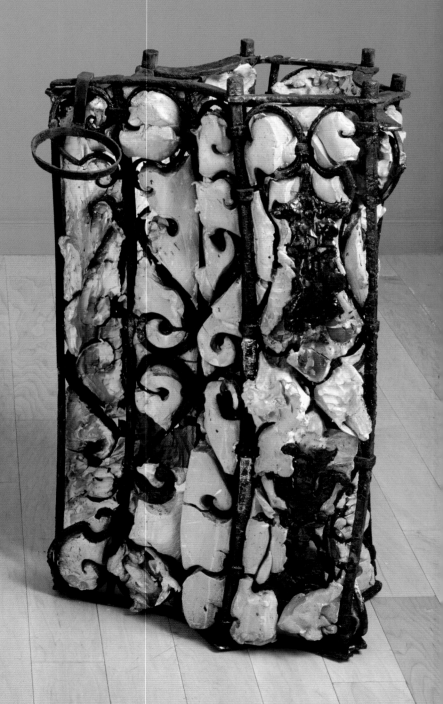

Angel Otero, *Veranda (Sca02)*, 2013

Adler Guerrier, *Untitled (Place marked with an impulse, found to be held within the fold) iv*, 2019

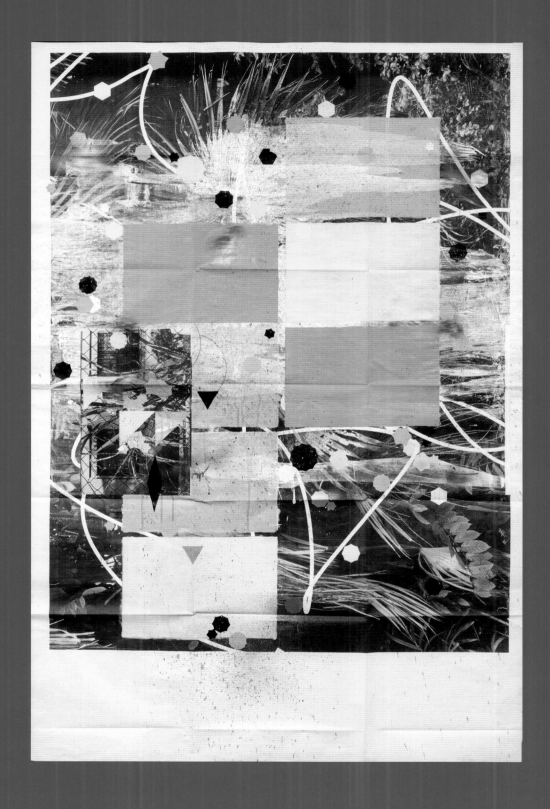

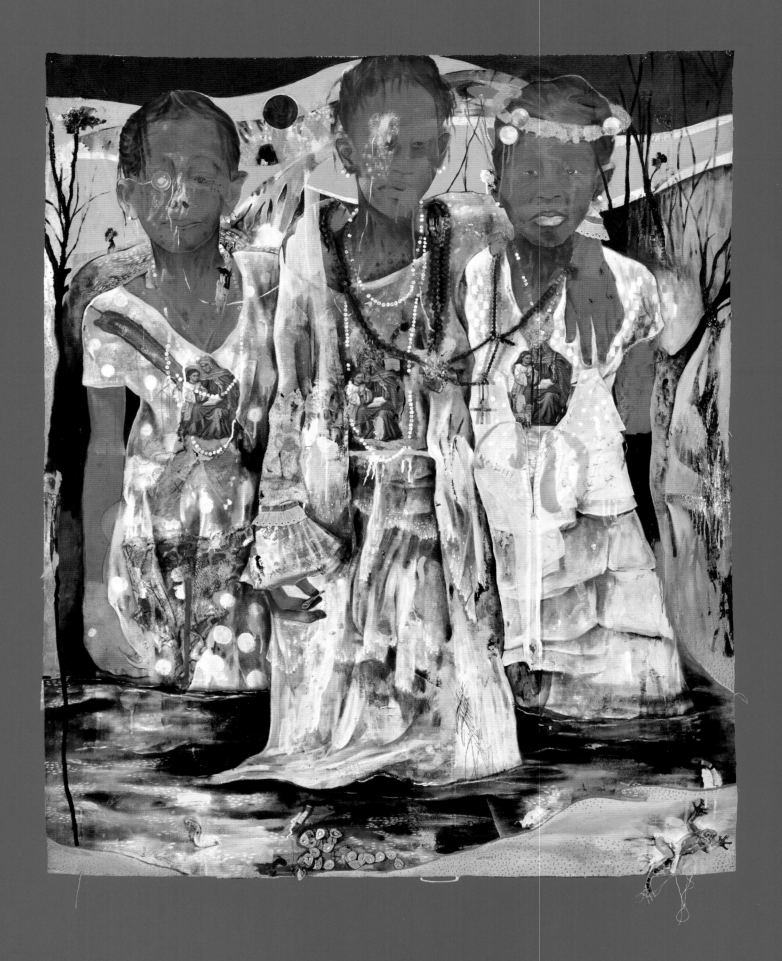

Lavar Munroe, *Church in the Wild*, 2019

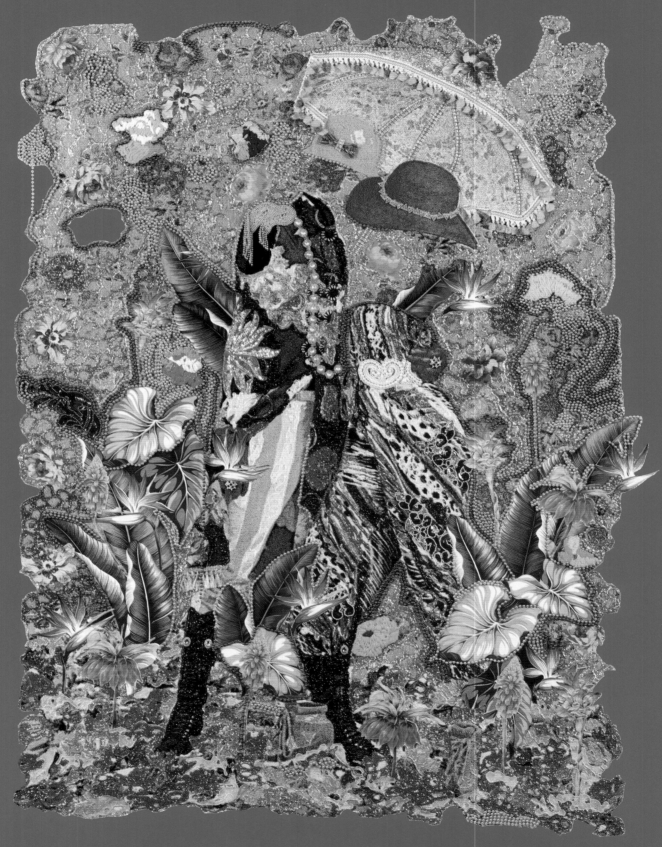

Ebony G. Patterson, *A View In*, 2015

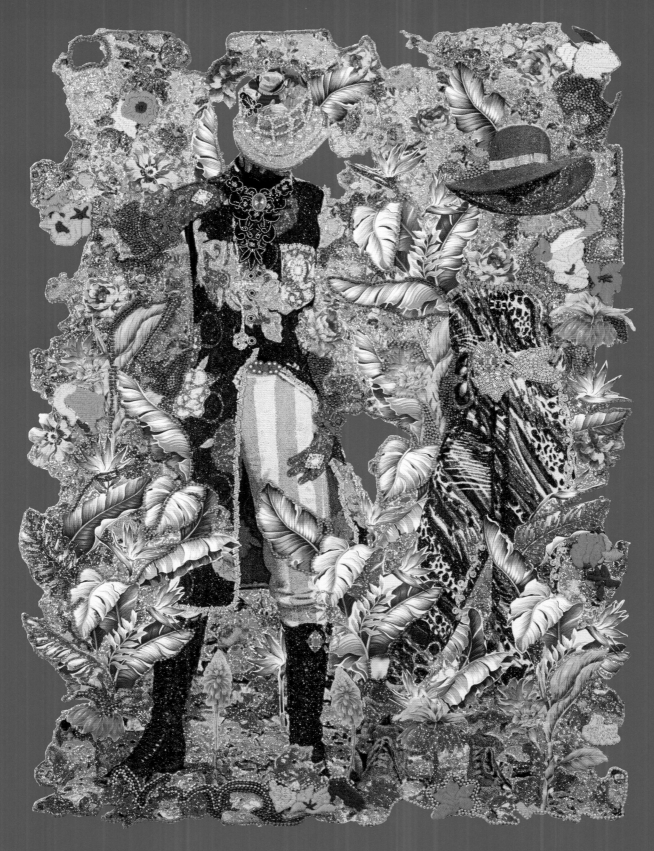

Ebony G. Patterson, *A View Out*, 2015

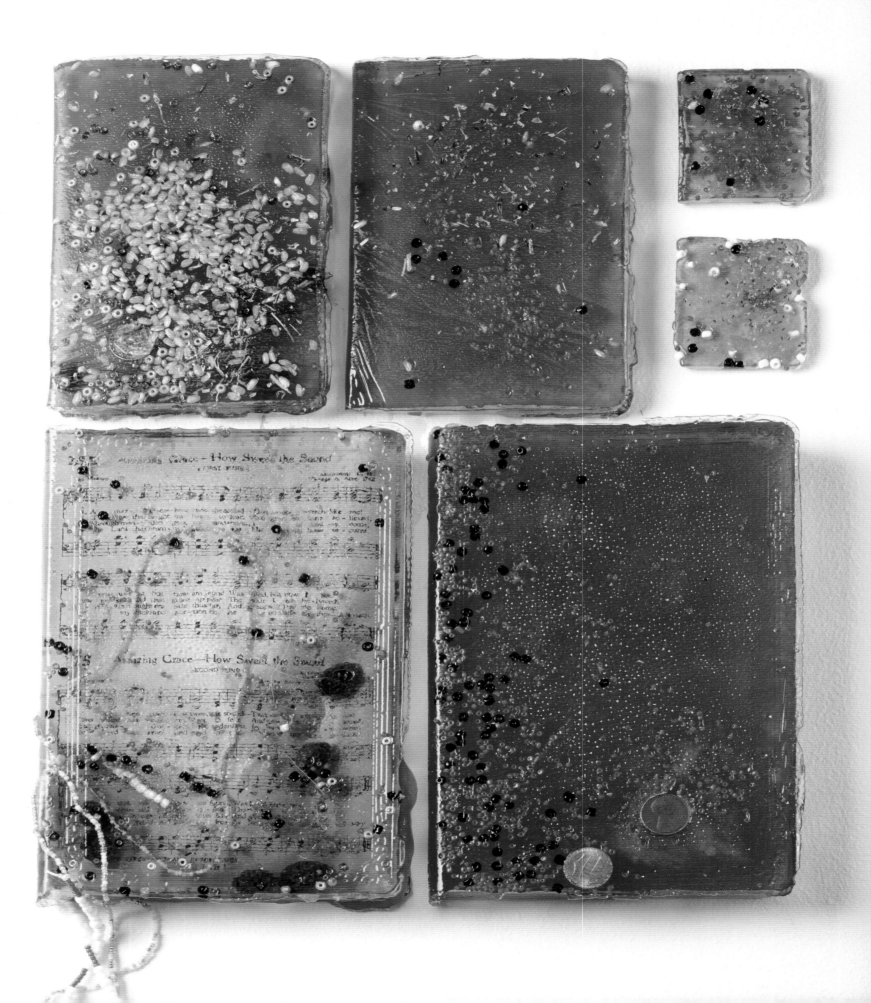

Andrea Chung, *Proverbs 12:22* (detail), 2019

OVERLEAF: Firelei Báez, *How to slip out of your body quietly*, 2018

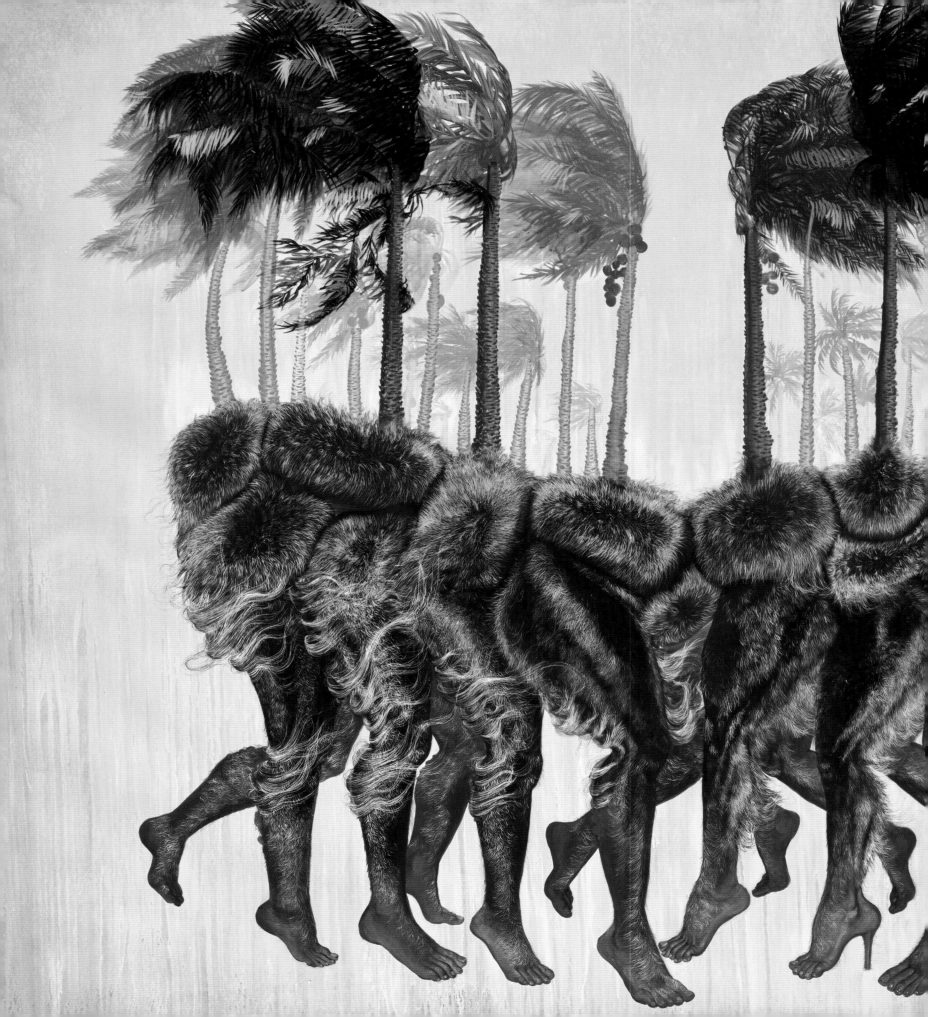

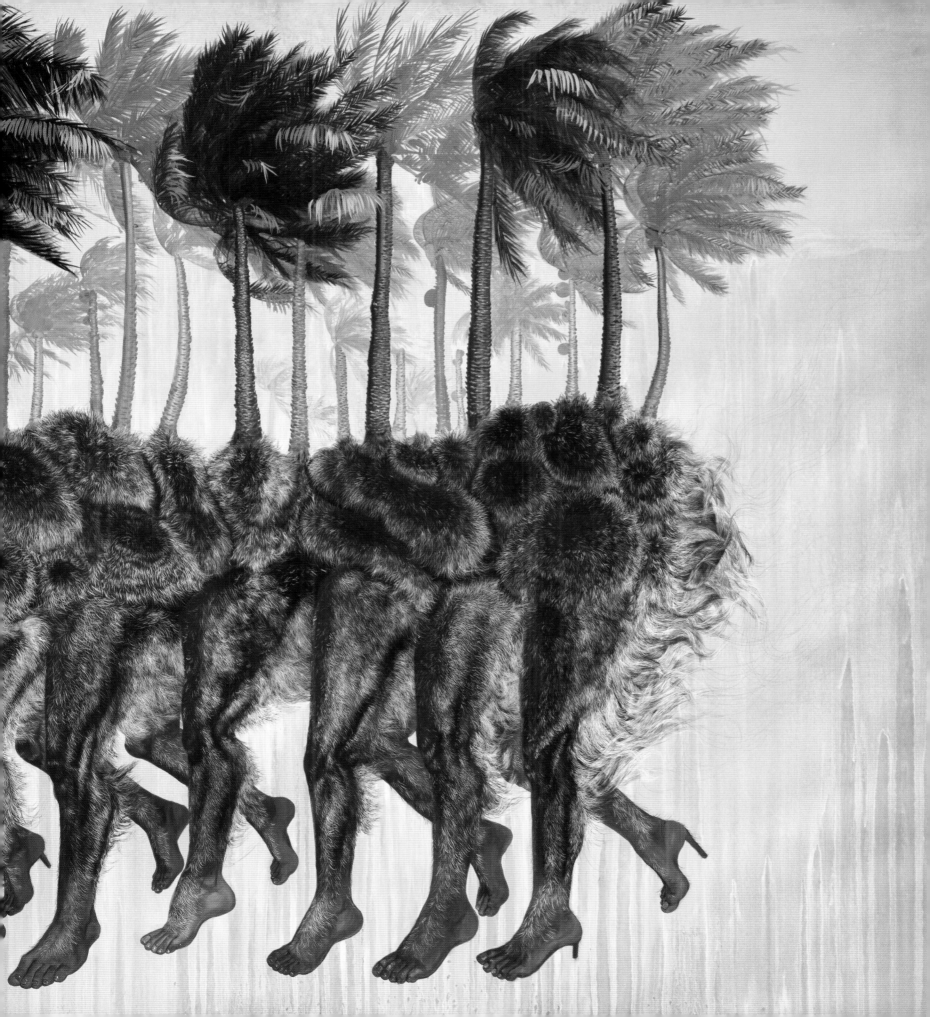

Angel Otero, *"Slots" Sl#1 (SCA03)*, 2013

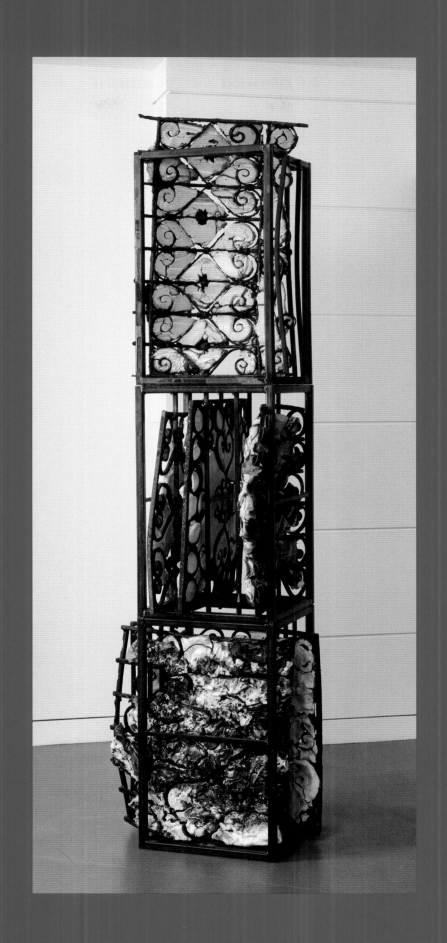

Didier William, *"Lonbraj mwen se kouwon mwen"* 1, 2019

Didier William, *"Lonbraj mwen se kouwon mwen" 2*, 2019

OVERLEAF: Lavar Munroe, *Beast of the Night*, 2018 (left); *Caged Beast*, 2018 (right)

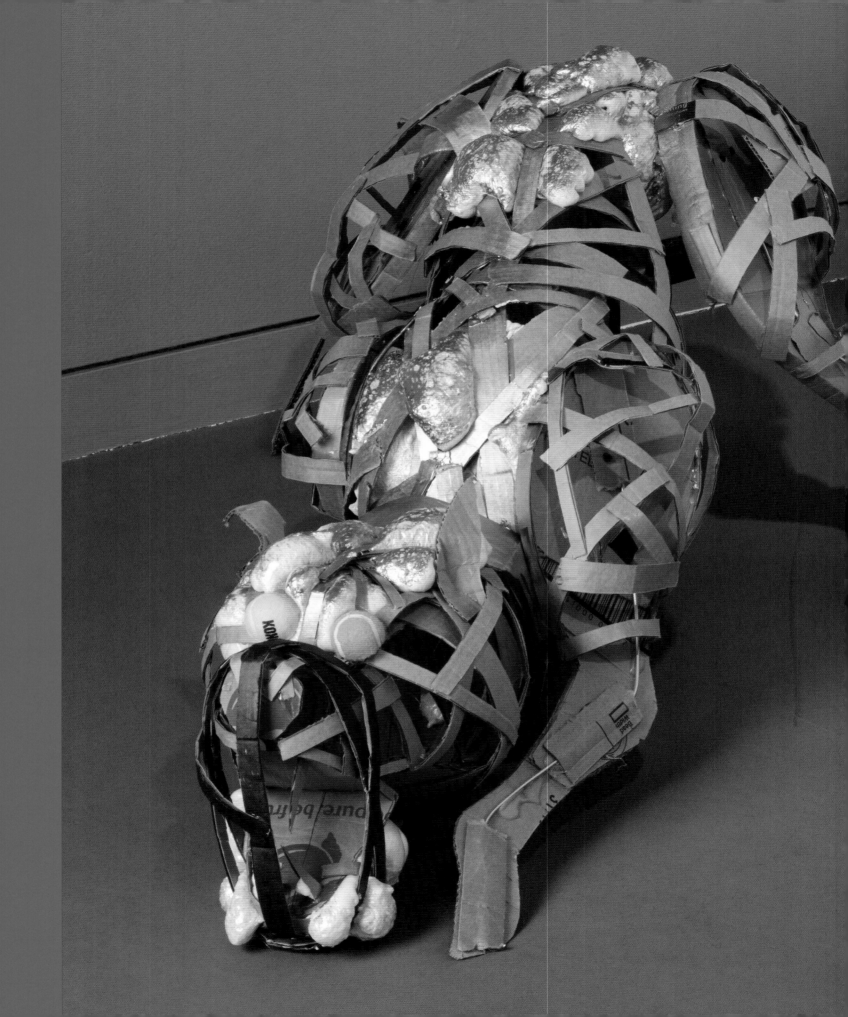

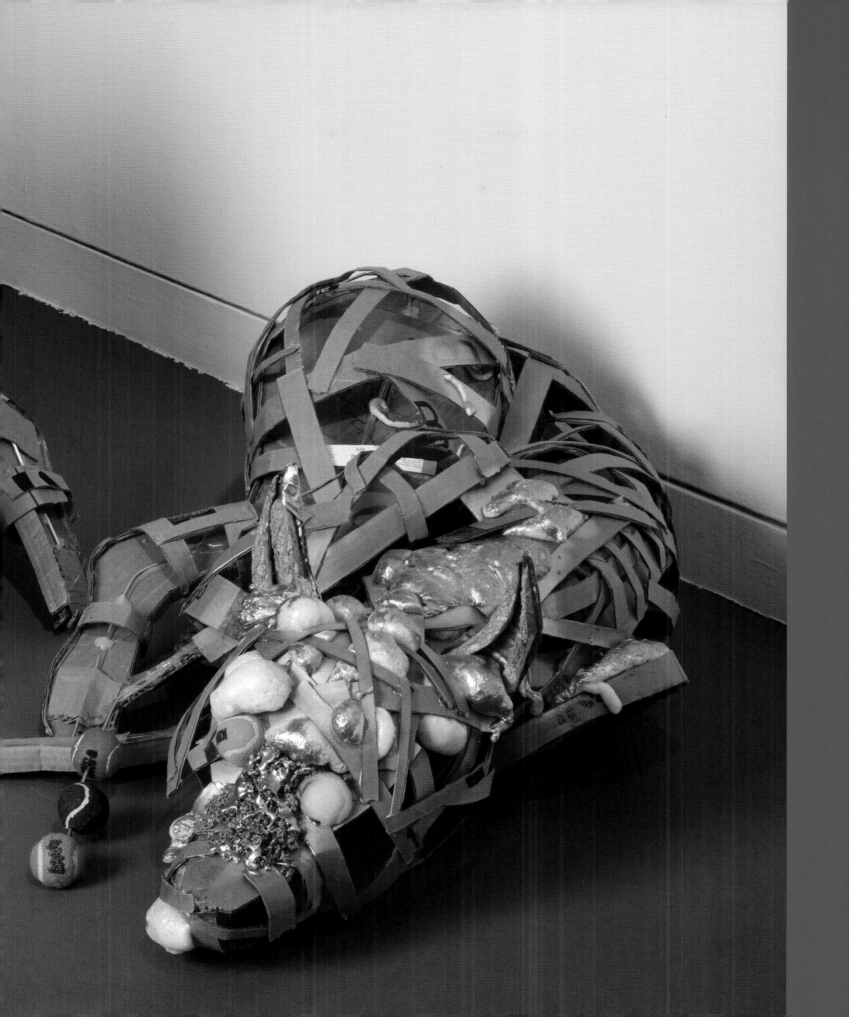

Firelei Báez, *Compulsion to remember and repeat*, 2016

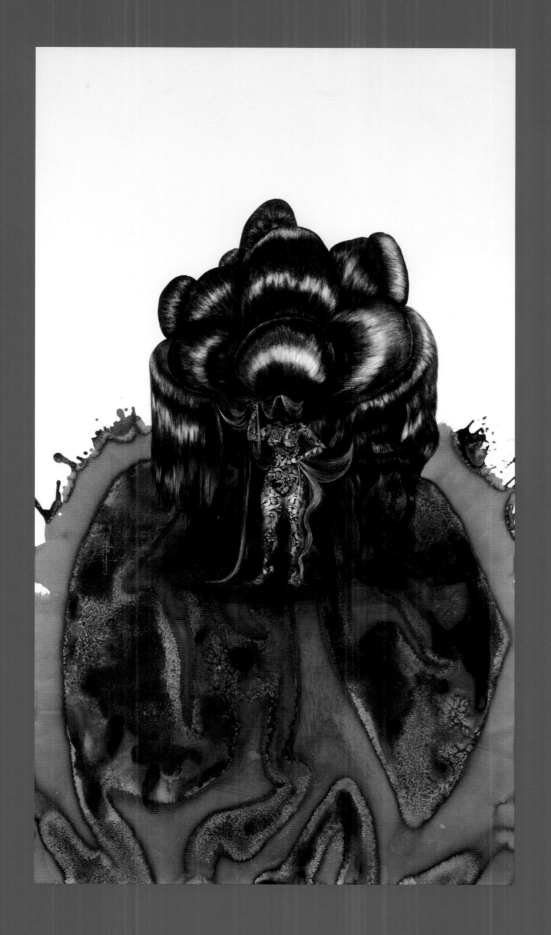

Adler Guerrier, *Untitled (blck-Devoted to the cause and improvement)*, 2018

OVERLEAF: Installation image: Lucia Hierro, *Embajador*, 2017 (foreground);
Aesthetics y Politics, 2019 (background)

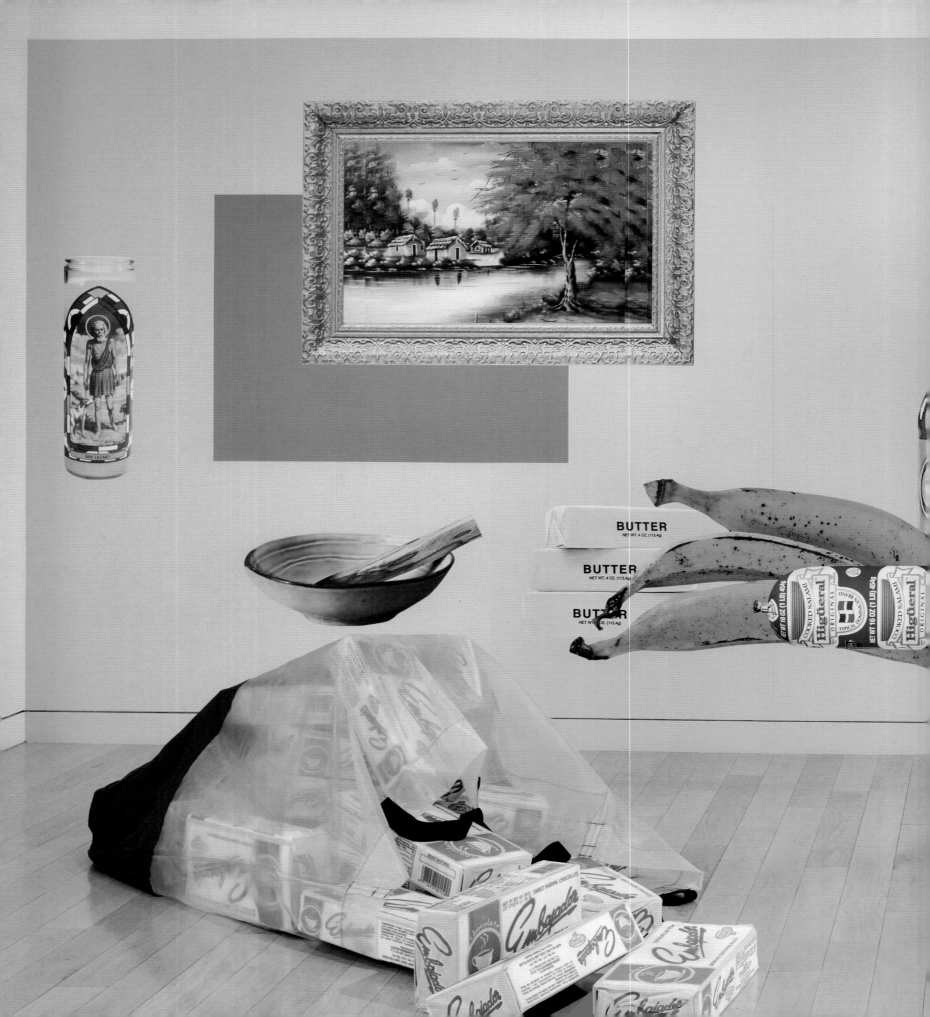

Juan Luis Guerra y
440

mudanza y acarreo

SCRATCH FREE

STRONGER THAN DIRT

AJAX
with BLEACH

ARRANCA
GRASA

AXION
100% EFECTIVO

The Economist

THE RISE OF

Soledad Angie Cruz

The Brief Wondrous
Life of Oscar Wao Junot Díaz

Pedro Mir POESÍA COMPLETA

Andrea Chung, *Proverbs 12:22*, 2019

Leonardo Benzant, *The Tongue on the Blade: Serenade for Aponte and All Those Who Have Vision*, 2017

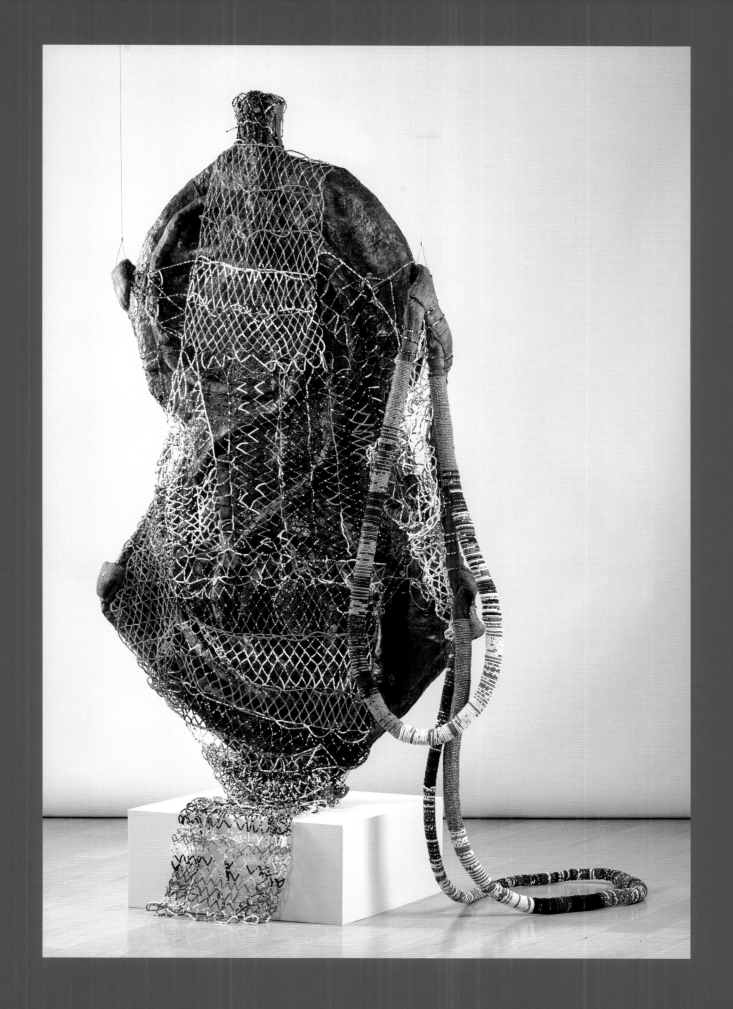

Adler Guerrier, *Untitled (Presence in this place is contingent on forms; Sugarcane) I*, 2019

OVERLEAF: Lavar Munroe, *And the Dogs Went Silent: Gun Dog 2,* 2017 (left); *And the Dogs Went Silent: Gun Dog 3*, 2017 (right); *And the Dogs Went Silent: Gun Dog I*, 2017 (rear)

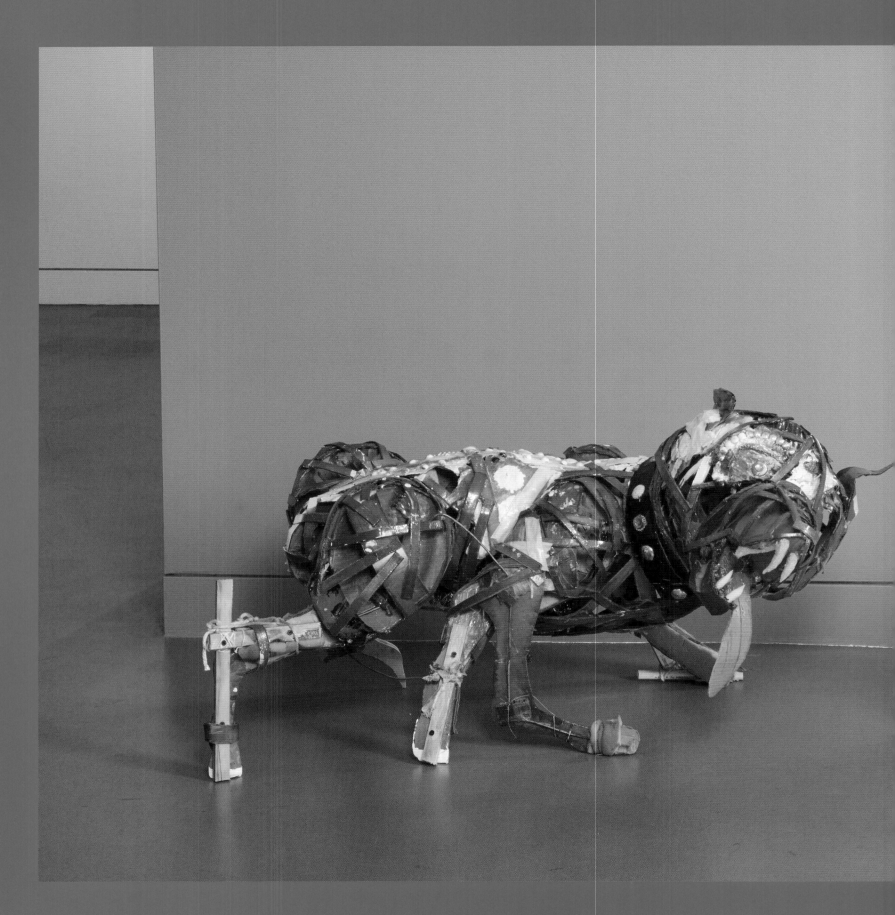

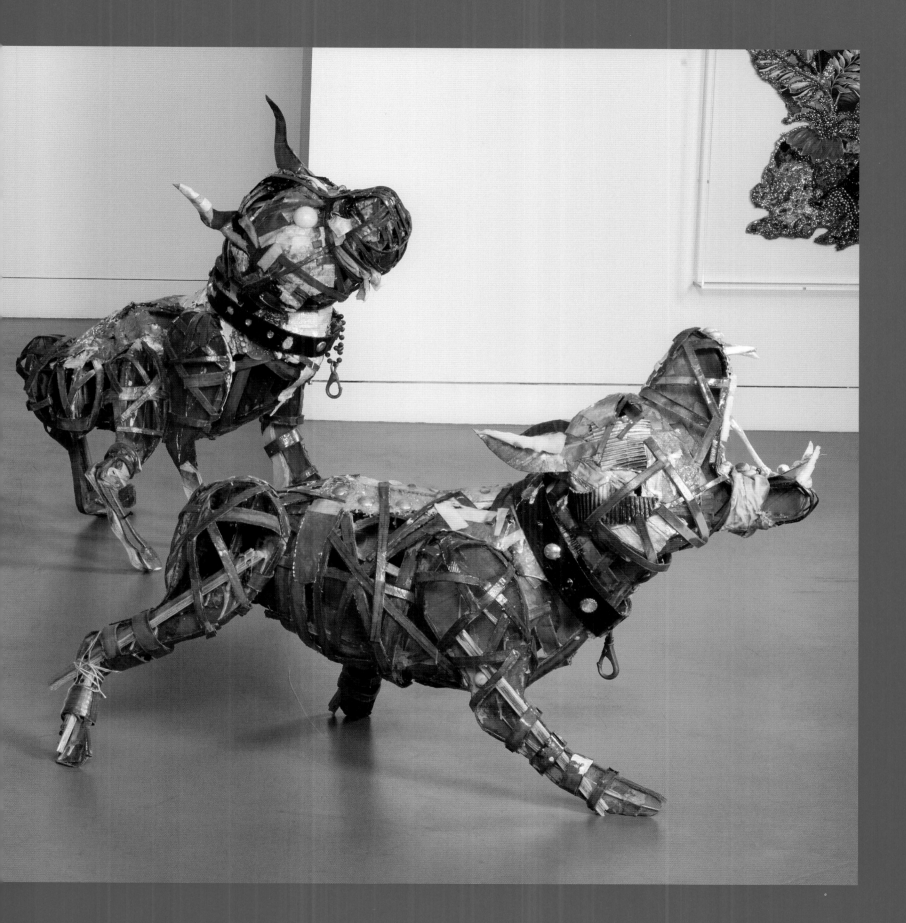

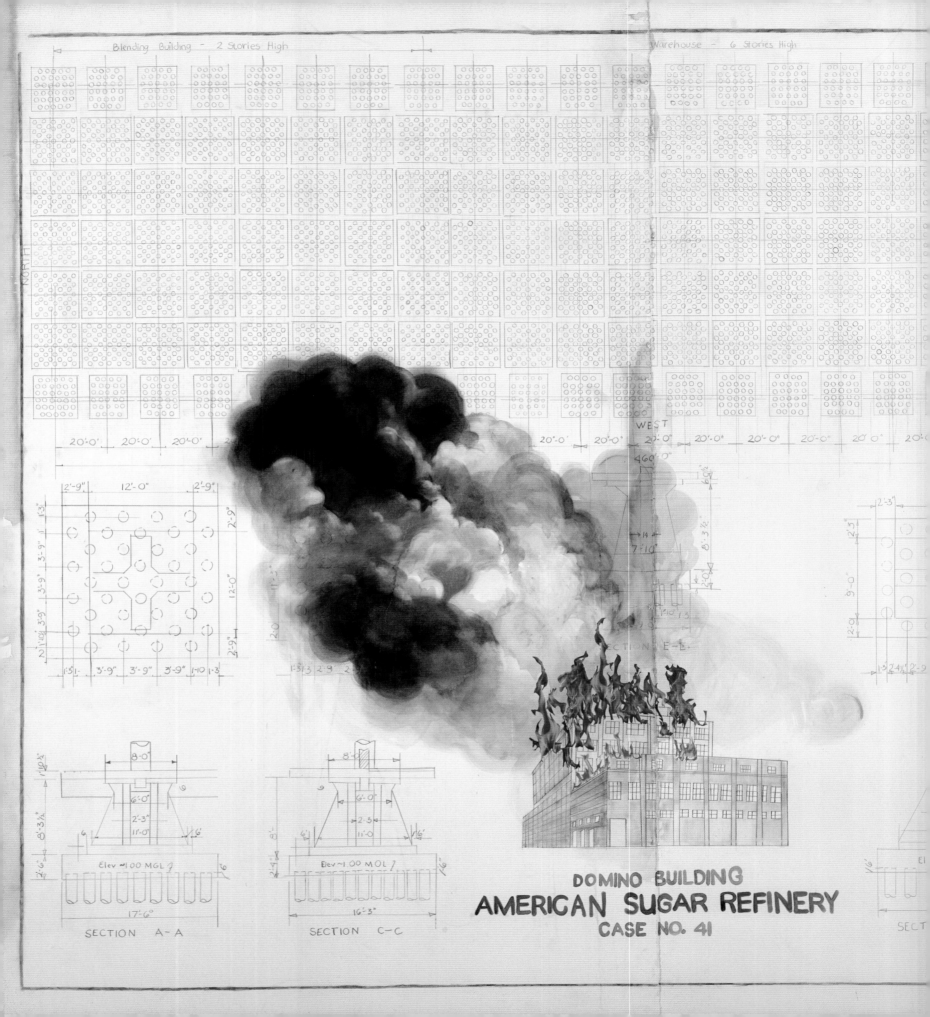

Blending Building - 2 Stories High

Warehouse - 6 Stories High

NORTH

20'-0" 20'-0" 20'-0" 20'-0" 20'-0" 20'-0" 20'-0" 20'-0" 20'-0"

WEST
460'-0"

2'-9" 12'-0" 2'-9"

2'-9"

12'-0"

2'-9"

1'-5" 3'-9" 3'-9" 3'-9" 1'-10 1'-3

1'-3 2'-9 2

SECTION E-E

8'-0"

8'-0"

6'-0"

6'-0"

2'-3"

2'-3"

11'-0"

11'-0"

Elev ~1.00 MGL

Elev ~1.00 MOL

17'-6"

16'-3"

SECTION A-A

SECTION C-C

SECT

DOMINO BUILDING
AMERICAN SUGAR REFINERY
CASE NO. 41

Firelei Báez, *Love that does not choose you (Collapse the rooms
and structures that depend on you to hold them)*, 2018

Didier William, *"Lonbraj mwen se kouwon mwen" 3*, 2019

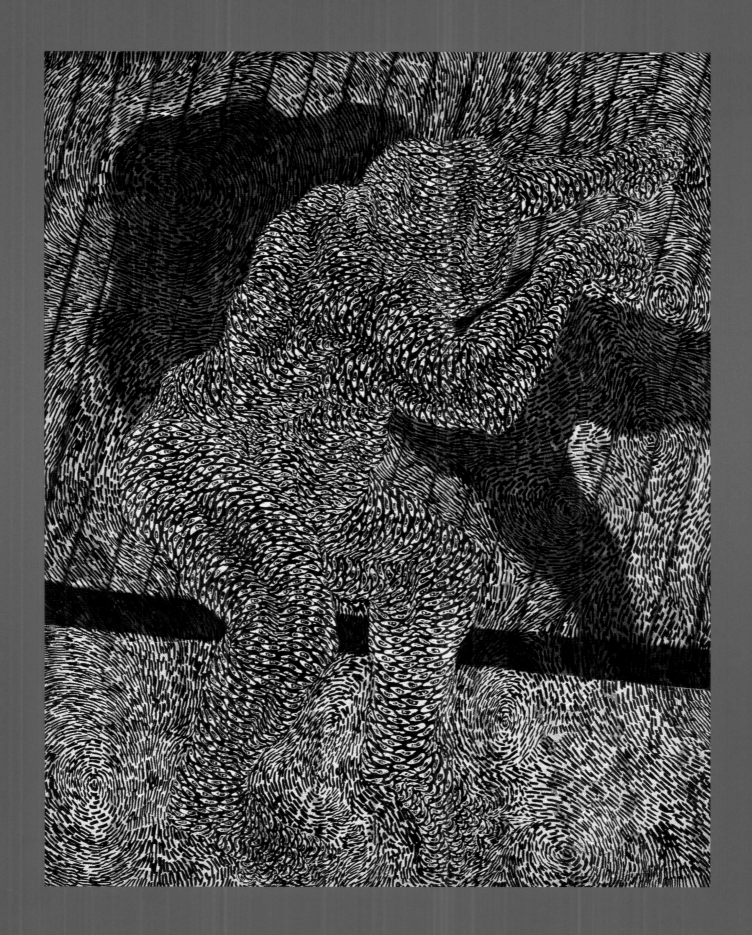

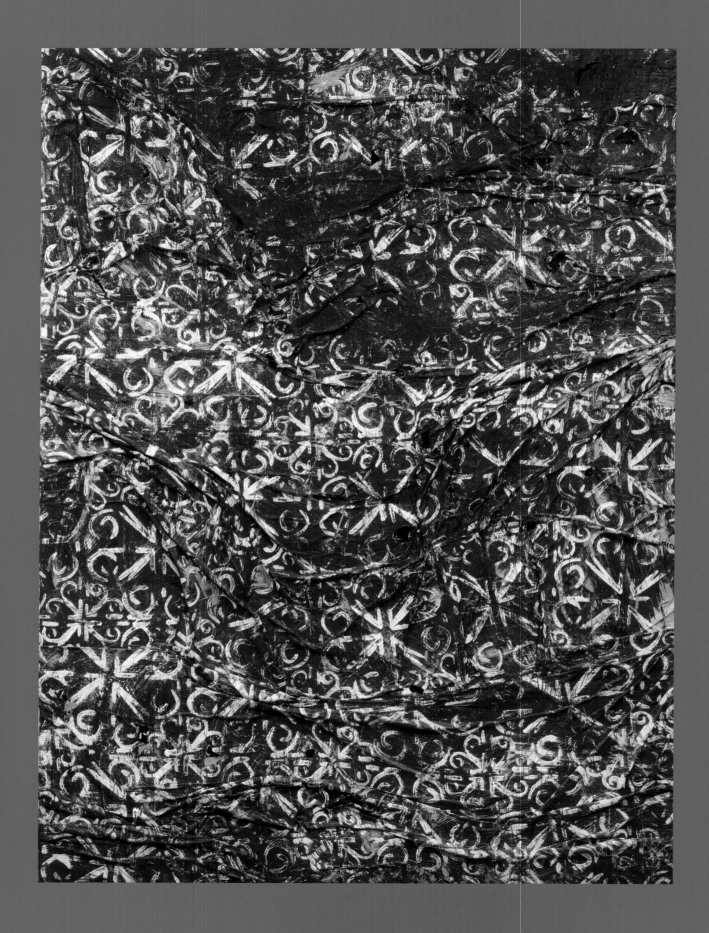

Angel Otero, *Untitled*, 2013

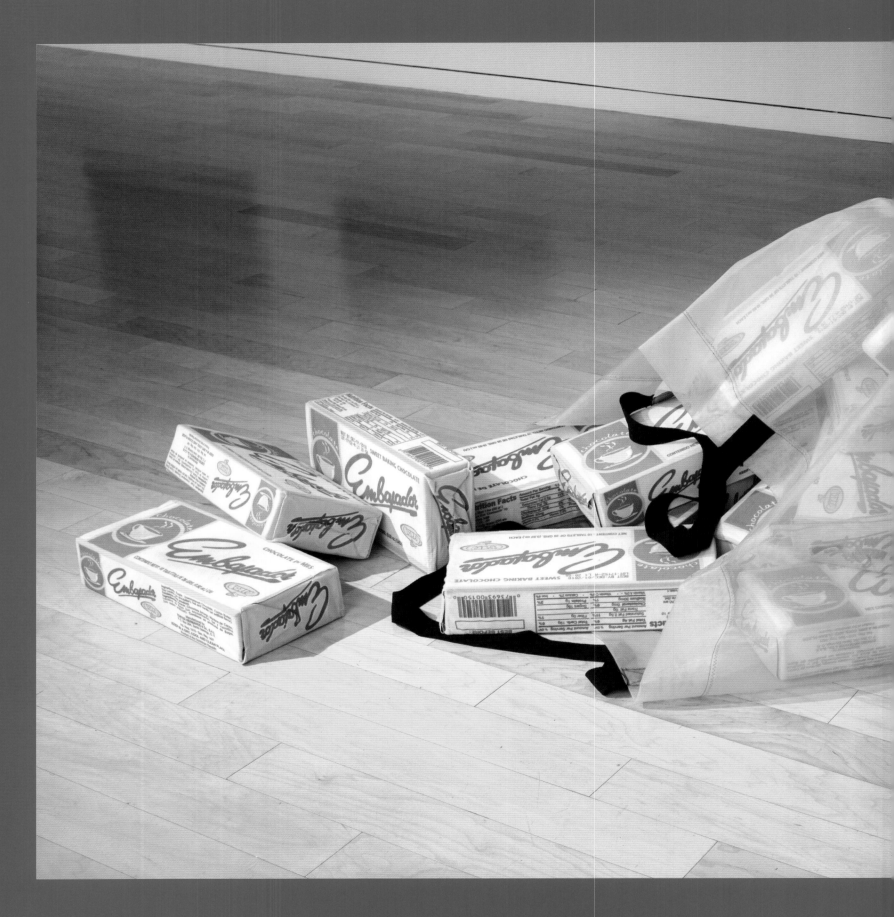

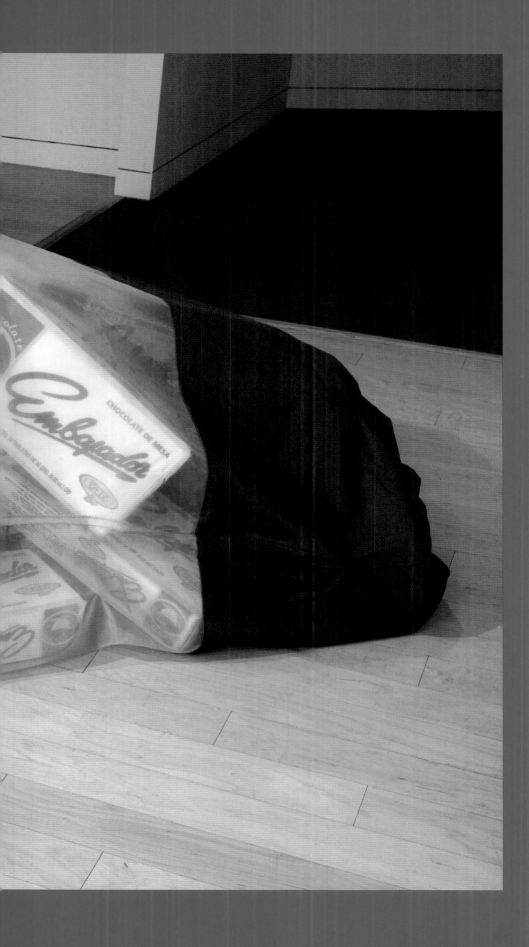

Lucia Hierro, *Embajador*, 2017

Lavar Munroe, *Spy Boy*, 2018

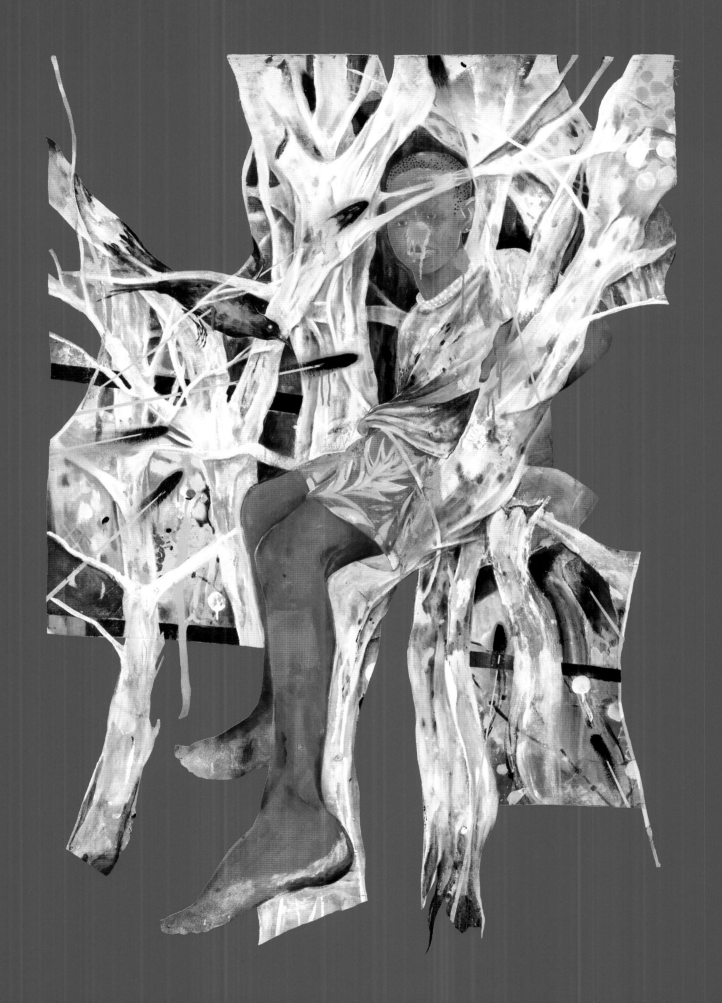

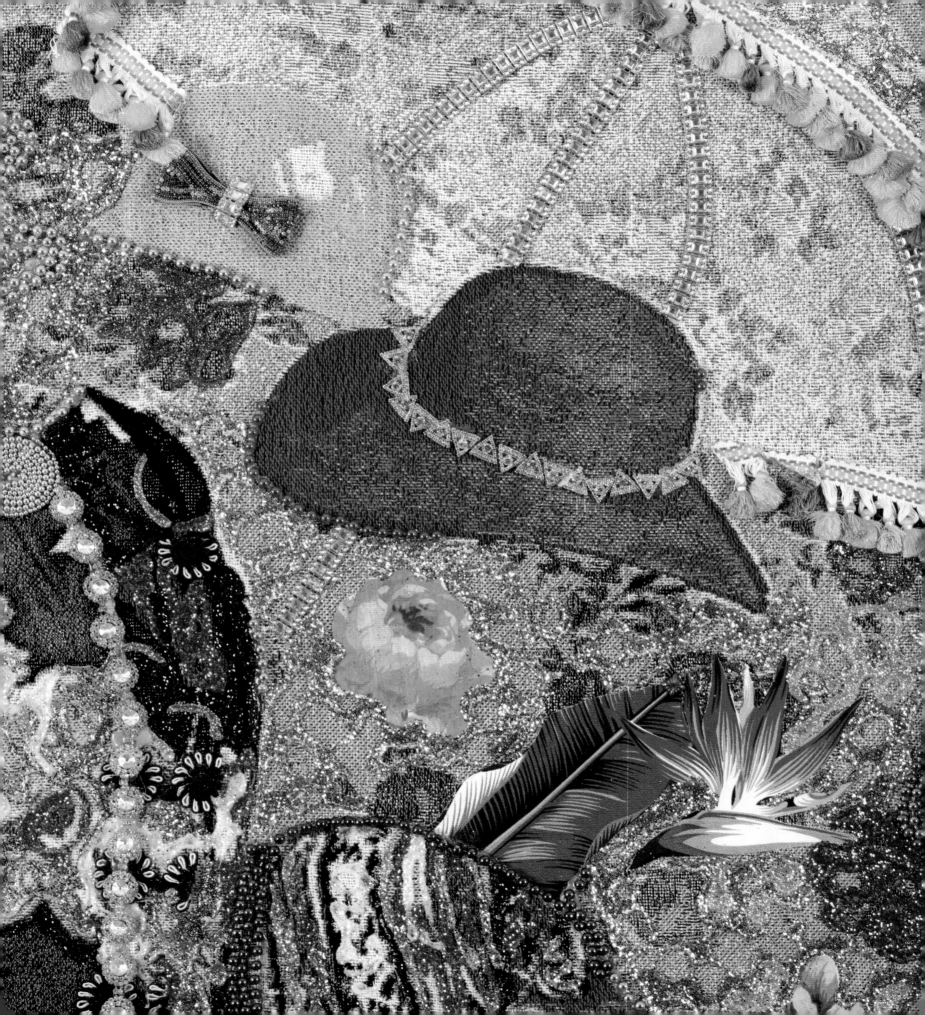

EDDIE CHAMBERS

Art History, African Diaspora Art
University of Texas at Austin

Can the following really be the case: "Coffee, rum, sugar, and gold remain highly valuable commodities and commercially important goods. However, because of their ubiquity and the passage of time, these items have lost much of their historical gravity and visibility as key drivers of European colonialism"?[1] Perhaps so, in the minds of certain people, but artists from the Caribbean and its diasporas are here to let us know that, to them, these commodities have lost little of their toxicity and venom as signifiers of troubled histories.

Those alive to ever-present signifiers of enslavement and colonialism have to look no further than the average bottle of rum. Either the labels contain supposedly comforting artistic renderings of benevolent plantation scenes (Myers's Jamaican rum being one example), or they boldly and proudly declare that the product has a centuries-old manufacturing pedigree. "Perfected by tradition since 1703" appears on the labels of Barbadian Mount Gay rum. We don't have to do much speculating as to what sorts of people were obliged to do pretty much all of the work in the manufacturing of rum, from the planting and harvesting of sugarcane to the loading of barrels of the finished product onto ships docked in Caribbean ports, from the early 1700s onward. The Caribbean rum industry was founded on the backs of enslaved people, a fact somewhat inadvertently, but proudly, declared on the labels of rum bottles.

Artists as varied as María Magdalena Campos-Pons (b. Cuba, 1959) and Keith Piper (b. Malta, 1960) have produced fascinating, forceful work commenting on the ways in which accessible signifiers of the torment, violence, and depravity heaped on New World Africans are hidden in plain sight. And now *Coffee, Rhum, Sugar & Gold: A Postcolonial Paradox* brings together the works of ten artists—Firelei Báez, Leonardo Benzant, Andrea Chung, Adler Guerrier, Lucia Hierro, Lavar Munroe, Angel Otero, Ebony G. Patterson, Phillip Thomas, and Didier William—that cogently reflect on the legacy of European colonialism in the Caribbean.

In pondering this collective body of work, we have to be mindful of several considerations, though they perhaps now exist as truisms in the realm of Caribbean art. While the *theory* of diaspora lies at the heart of art practices related to the Caribbean, the *practice* of diaspora is an altogether more diffused manifestation. We know that a major contributory factor in the creation of the African diaspora was the transatlantic slave trade and the

Detail of Ebony G. Patterson,
A View In, 2015

making over of the New World as parts of the world primarily populated by those of African origin. But over the course of a half century or more, we have seen what is in effect a distinct transmutation of the African diaspora, which has led to the creation of any number of secondary diasporas. As much as these ten artists can be read as artists of the African diaspora, they also belong to various respective diasporas—those of the Bahamas, the Dominican Republic, Haiti, Jamaica, and Puerto Rico. People from these and other Caribbean nations have established themselves as oftentimes distinct communities linked to, but very much different from, the respective home nations that gave rise to successive waves of immigration to the United States. And each of these secondary diasporas often functions with its own set of cultural reference points, complex sense of nationhood, and constantly shifting sense of belonging and unbelonging. Furthermore, as much as Báez, Benzant, Chung, and company can be seen as artists of the African diaspora, they can also be read as artists whose practices and identities have emerged from distinctly US-based contexts. Living and working in different parts of the United States, they are very much *American* artists.

Each of these artists represents the ways in which diaspora contains multiple lenses and is a dispersing and overlapping consideration, even more than it might be any sort of unifying one. The last time I saw Andrea Chung's work was in *Circles and Circuits I: History and Art of the Chinese Caribbean Diaspora*, at the California African American Museum, alongside artists such as Albert Chong and María Magdalena Campos-Pons. The exhibition encouraged its audiences to comprehend not only the work on view, but also the multiple, largely untold and unconsidered stories that informed "the 200-plus-year history of the Chinese diaspora in the Caribbean and how art has played a pivotal role in depicting these historically silenced narratives."[2]

An exhibition that looks at the legacy of European colonialism in the Caribbean is somewhat challenging because many in the Caribbean would wish to banish the lingering shadow of colonialism from all vestiges of national identity. How could it be otherwise? For example, in the period leading up to Jamaica gaining its independence, it embarked on a concerted program of building a new national cultural identity. New flag, national anthem, national flower, national bird, national fruit, national motto—the list goes on. A measure of this determined strategy of colonial disentanglement can be ascertained by the ways in which the colonial power, Great Britain, had

precious few of these national symbols. It had, of course, a national flag and anthem. But who knew what might be Great Britain's national dish? National fruit? National bird? Such things were, it seems, the preserve of newly independent nations, keen to flex their new national cultural identity muscles, not only within the reborn and reimagined nation-state, but also on the world stage. Indifference to this arguably strained, forced, and mannered lexicon of national iconography was simply not an option on the part of Jamaica's citizenry. At independence, Jamaica's populace, as with that of many other nations across the Caribbean, found itself shoehorned into the somewhat unimaginative and overly problematic constraints of the nation-state. As with other nations of the Caribbean, it would take the gradual emergence of multiple Jamaican and other Caribbean diasporas to complicate and undermine the attempted monolithic construction of the nation-state.

The previously mentioned concerted attempts at nation-building contrasted sharply with what might be a noticeable ambivalence within the diasporas, spawned by no end of Caribbean countries, to anything that resembled allegiance to any sort of fixed, rigid, nationalistic definition of a nation-state, particularly one that required and sought the allegiance of compliant citizens. After all, it is inarguably the case that the colonial nation-state had conclusively failed its Black citizens and continued its bloody mission to keep them in various states of marginalization and abjection. Think Windrush scandal,[3] for example. As British historian Paul Gilroy observed, "the African diaspora's consciousness of itself has been defined in and against constructing national boundaries."[4] We would do well to consider just where European colonialism fits in all of this.

Turning to *Coffee, Rhum, Sugar & Gold*, viewers will very likely note the ways in which sugar features as subject matter for several artists, as well it

might, given that Caribbean countries such as British Guiana existed for the absolute sole purpose of the manufacturing and exporting of sugar. (Were it not for the ravages of diabetes among populations of the African diaspora, we might regard the infinitely destructive capabilities of sugar as history's revenge, particularly given that sugar is not a food and interacts with the human body with characteristics more akin to a narcotic than a form of edible nourishment.) In Firelei Báez's *Love that does not choose you (Collapse the rooms and structures that depend on you to hold them)* (2018), we see, in the first instance, something resembling a conflagration, an inferno, as it takes control of a building. The building turns out to be Brooklyn's legendary Domino Sugar Refinery. The former refinery in the Williamsburg neighborhood of Brooklyn was home to the American Sugar Refining Company, producers of the ubiquitous Domino brand of sugar. In its day, the nineteenth-century building was the largest sugar refinery in the world. Now it is the centerpiece of the gentrification of that Brooklyn neighborhood and was dramatically utilized by Kara Walker for the making of her 2014 installation, *A Subtlety*, the central component of which was a massive, sugar-coated sphinx-like woman. On closer inspection of Báez's work, we see that the depiction of the burning building overlays what look to be an architect's drawings of plans for the Domino Sugar Refinery.

Where to begin? The meticulous plans might bring to mind the plan of the slave ship *Brookes* of Liverpool, which depicts the commodified packing of enslaved Africans into the decks of the vessel. People were rendered as if they were no more, or no better, than inanimate objects, evocative of those shown in plans produced to further the vision (if that's not the wrong word) of capitalists and wealth acquirers from time immemorial. Terry Boddie (b. Nevis, Saint Kitts and Nevis, 1965) has produced a memorable artwork that creates an equivalence between the packing of enslaved Africans in the hold of a slave ship and the latter-day packing of their descendants into decidedly inadequate and unsatisfactory living conditions in America's inner cities. In Báez's *Love that does not choose you (Collapse the rooms and structures that depend on you to hold them)*, we see the manifestation of the architect's plans, the Domino Sugar Refinery, in the process of being razed to the ground by fire, that most primeval and biblically judgmental of elements. This brings to mind Gregory Isaacs's "Slave Master," which saw the singer adopting the guise of a would-be insurrectionist, enslaved on the plantation.

Installation image, MoAD, 2019

COFFEE
RHUM
SUGAR
& GOLD
A POSTCOLONIAL PARADOX

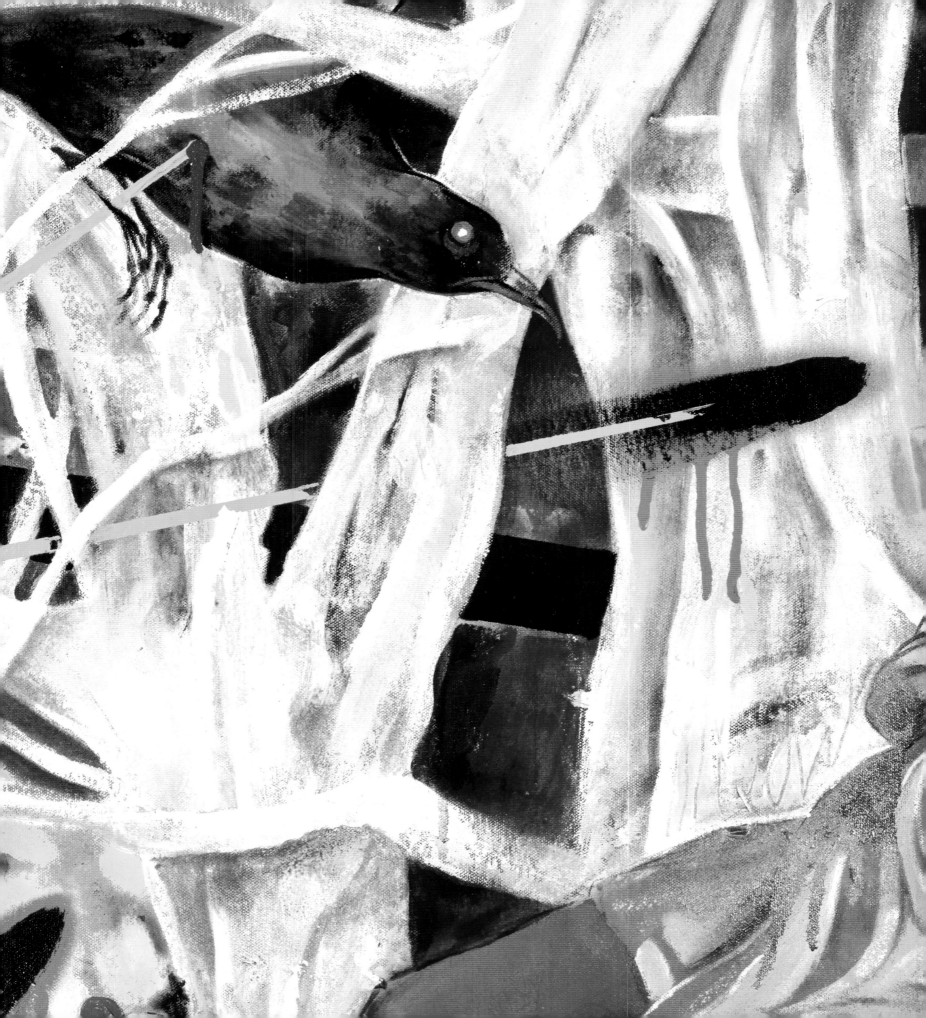

LEFT: Detail of Lavar Munroe, *Spy Boy*, 2018

OVERLEAF: Installation image, MoAD, 2019

[1] Museum of the African Diaspora (MoAD), blog, https://www. moadsf.org/event/curator-artists-talk-coffee-rhum-sugar-gold-a-postcolonial-paradox/.

[2] "Panel: Albert Chong, Andrea Chung and María Magdalena Campos-Pons, moderated by Lok Siu," Talks and Workshops, California African American Museum (CAAM), https://culturela.org/event/panel-discussion-circles-and-circuits-i-history-and-art-of-the-chinese-caribbean-diaspora/.

[3] In 2018, the Windrush scandal occurred in Britain when the Home Office wrongly detained people, denying their legal rights, threatening them with deportation, and, in at least 83 cases, wrongly deporting them.

[4] Paul Gilroy, *There Ain't No Black in the Union Jack: The Cultural Politics of Race and Nation* (London: Hutchinson, 1987).

[5] "Firelei Báez," Artsy (website) https://www.artsy.net/artist/firelei-baez-1.

[6] "Firelei Báez," About the Artists, Kohn Gallery, http://www.kohngallery.com/engender.

[7] "Sink & Swim," Andrea Chung Art, http://andreachungart.com/2013-2/sinkandswim/.

. . . But if I don't get my desire

Then I'll set the plantations on fire . . .

This dramatic, multilayered, and deeply nuanced work sees New York–based Báez continuing her investigations of "issues of identity construction in her paintings, collages, and drawings."[5] Whether geographical or cultural, selfhood for Báez is malleable, and she uses art to articulate a complex formulation of her Caribbean background. Her visually striking work serves as a defense against culturally predetermined ethnic stereotypes and as an attempt to unite communities dispersed across the globe. The artist uses "humor and the imagination to create alternate environments in which cultures, disparate or alike, can commune."[6]

Perhaps even more than coffee, rum, and gold, sugar is the colonially derived commodity that most exercises artists. Improbably perhaps, Andrea Chung's work in *Circles and Circuits I: History and Art of the Chinese Caribbean Diaspora*, and presented again in *Coffee, Rhum, Sugar & Gold*, manages to bring together investigations into the materiality of sugar with Mauritanian histories of fishing. This is a most intriguing, arresting, and necessarily *messy* installation.

> After the abolition of slavery on the island of Mauritius, many newly freed slaves (also known as Creoles) became fishermen and subsequently established small fishing villages, particularly in the southern part of the island, rather than return to the cane fields to work for their former enslavers. Many of these fishing villages remain today and these fishing traditions have been passed down for generations. Unfortunately, the trade is now threatened due to overfishing.

> I cast liquor bottles out of sugar to re-create a method of fishing used by some Mauritian fishermen. The bottles are accompanied with small metal and sugar replicas of fishing tackle, such as weights and hooks, and are wrapped and entangled in fishing line. As I cast the bottles, they are hung and left to the elements of the space. Over time the bottles melt, dematerialize, and shatter, reflecting the disappearance of both a community and a trade.[7]

Each of the ten artists in this exhibition sees to it that questions, rather than answers, are generated by their practices.

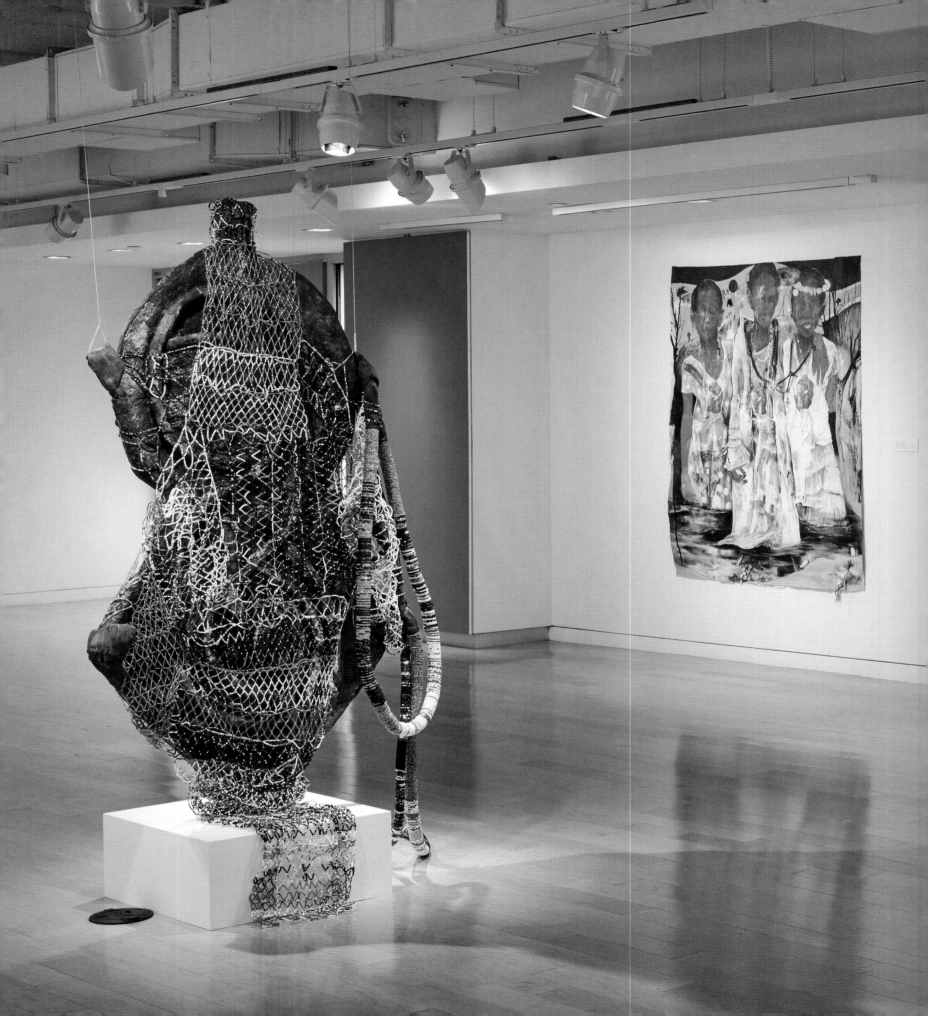

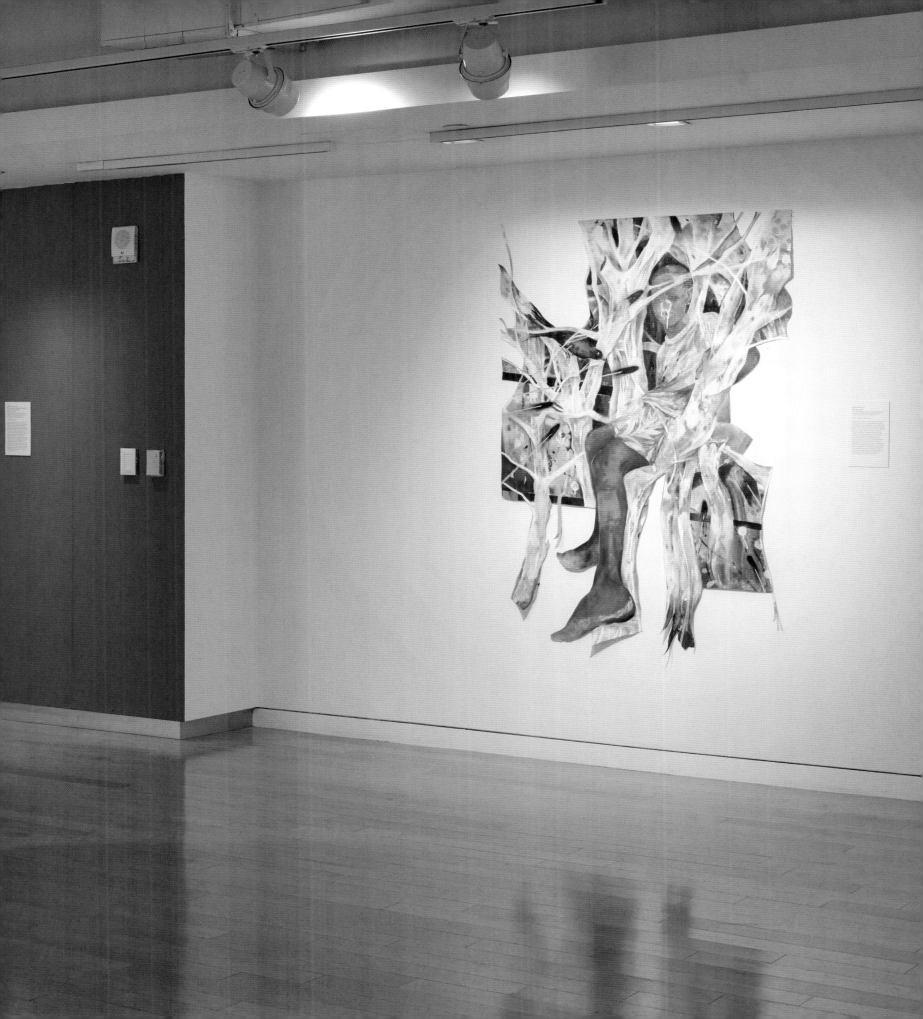

ARTIST BIOGRAPHIES

Firelei Báez (b. 1981, Dominican Republic) received an MFA from Hunter College and studied at the Skowhegan School of Painting and Sculpture. Báez's work ties together subject matter mined from a wide breadth of diasporic narratives. Her work is the subject of 2019 solo exhibitions at the Witte de With Center for Contemporary Art, Rotterdam, the Netherlands, and the Mennello Museum of Art, Orlando, Florida. The artist recently participated in the 2018 Berlin Biennale, and her work belongs to the permanent collections of the Studio Museum in Harlem and Pérez Art Museum Miami, among others.

Leonardo Benzant (b. 1973, Brooklyn, NY) is a Dominican-American artist with Haitian heritage, born and raised in Brooklyn, whose work is informed by his studies of the Kongo and his spiritual beliefs shaped by research into western, eastern, African, and Caribbean religion, art, history, culture, and rituals. Benzant's work was featured in the solo exhibition *Afrosupernatural* at Aljira, a Center for Contemporary Art in Newark, NJ. He has participated in group shows at the Third Line, Dubai, and the N'Namdi Center for Contemporary Art, Detroit, among other venues. From 2016–2017, he was a resident at the Galveston Artist Residency.

Andrea Chung (b. 1978, Newark, NJ) lives and works in San Diego, CA. She received a BFA from Parsons School of Design and an MFA from Maryland Institute College of Art. Her recent biennale exhibitions include *Prospect.4* and the Jamaican Biennial. In 2017, her first solo exhibition, *You broke the ocean in half to be here*, took place at the Museum of Contemporary Art San Diego. Her residencies include the Vermont Studio Center and Headlands Center for the Arts, among others. Her work has been written about in ArtFile Magazine, the *Los Angeles Times*, and in numerous academic essays on the subject of colonialism and slavery in the Caribbean.

Lavar Munroe (b. 1982, Nassau, Bahamas) attained an MFA from Washington University in St. Louis, and attended the Skowhegan School of Painting and Sculpture. His work reflects his upbringing in an impoverished community in the Bahamas, and maps a personal journey of survival. Munroe was a participant in *Prospect.4* and the 56th Venice Biennale. He recently had a ten-year survey at the National Art Gallery of the Bahamas as well as a solo exhibition at the Meadows Museum of Art in Shreveport, LA. His additional exhibitions in 2019 include *Get Up, Stand Up Now* at the Somerset House and *The Other Side of Now* at Pérez Art Museum Miami. Munroe is a visiting professor at Indiana University.

Angel Otero (b. 1981, Santurce, Puerto Rico) received his MFA and BFA from the School of the Art Institute of Chicago. Solo exhibitions of his work have been organized at the Bronx Museum of the Arts, Contemporary Arts Museum Houston, and Centro Atlántico de Arte Moderno, among others. Group exhibitions and biennials featuring his work include *Inherent Structure* at Wexner Center for the Arts and *Surface Area* at the Studio Museum in Harlem. Otero is the recipient of the Leonore Annenberg Fellowship in the Visual Arts. His work can be found in numerous museum collections, including DePaul Art Museum and Istanbul Modern.

Detail of Adler Guerrier, *Untitled (Place marked with an impulse, found to be held within the fold) iv*, 2019

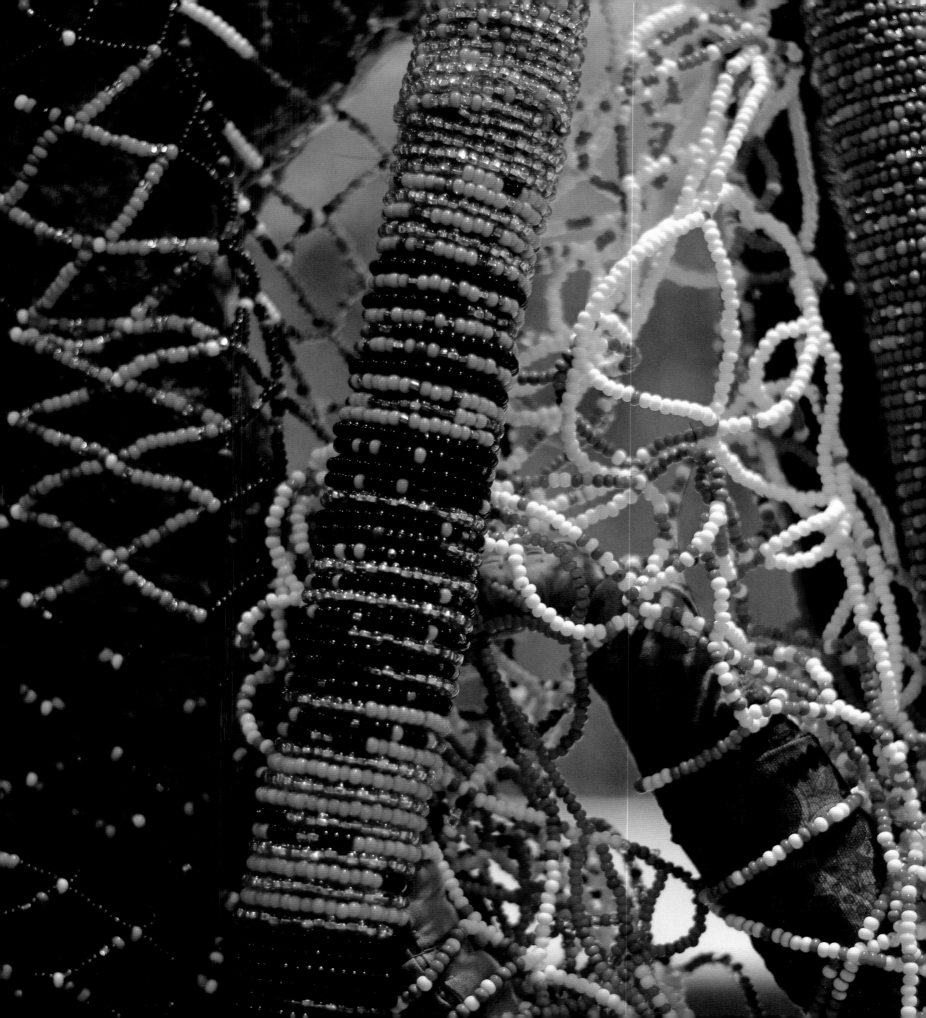

Lucia Hierro (b. 1987, New York, NY) is a Dominican-American conceptual artist currently working in the Bronx. She received a BFA from SUNY Purchase and an MFA from Yale School of Art. She has exhibited in shows at Tiger Strikes Asteroid, Bronx Museum of the Arts, and Paris Photo, among others. She recently had her first solo shows at Elizabeth Dee Gallery in Harlem and Casa Quien in the Dominican Republic. Residencies include: Yaddo, Red Bull Arts in Detroit, and Fountainhead Residency. Her series titled *Mercado* utilizes digital media, painting, installation art, sculpture, and color theory to tackle ideas of exclusion and privilege.

Adler Guerrier (b. 1975, Port-au-Prince, Haiti) improvises with a variety of materials and techniques to subvert constructions of race, ethnicity, class, and culture. Guerrier earned a BFA at the New World School of the Arts and recently had a solo exhibition at Pérez Art Museum Miami. He has exhibited work at Vizcaya Museum and Gardens, Miami; The Bass, Miami; Harn Museum of Art, Gainesville, FL; and the Whitney Biennial 2008. His works appears in such public collections as the Museum of Contemporary Art, North Miami, and the Studio Museum in Harlem. His work has appeared in *Artforum*, the *New York Times*, and *ARTnews*, among other publications.

Ebony G. Patterson (b. 1981 in Kingston, Jamaica) received her BFA from Edna Manley College and MFA from the Sam Fox School of Design & Visual Arts. Patterson has had solo exhibitions at Pérez Art Museum Miami and Atlanta Contemporary Art Center, among others. Her work was included in *Open Spaces Kansas City* (2018), *Prospect.3: Notes for Now* in New Orleans, and *Jamaica Biennial 2014*. She was an artist-in-residence at the Robert Rauschenberg Foundation and served on the Artistic Director's Council for *Prospect.4*. Patterson's work is included in such public collections as the Studio Museum in Harlem, Nasher Museum of Art, and the National Gallery of Jamaica.

Didier William (b. 1983, Port-au-Prince, Haiti) received his BFA in painting from the Maryland Institute College of Art and an MFA in painting and printmaking from Yale University School of Art. His work has been exhibited at the Bronx Museum of the Arts; the Fraenkel Gallery, San Francisco; Fredericks & Freiser gallery, New York; and Gallery Schuster in Berlin. He was an artist-in-residence at the Marie Walsh Sharpe Art Foundation in Brooklyn, and has taught at Yale School of Art, Vassar College, Columbia University, and SUNY Purchase. He is currently Assistant Professor in Expanded Print at Mason Gross School of the Arts at Rutgers University.

Phillip Thomas (b. 1980, Kingston, Jamaica) is a graduate of Edna Manley College and New York Academy of Art. His numerous solo and group exhibitions include the Jamaica Biennial, where he won the top prize for his painting *The N Train*. His work appears in a variety of public and private art collections, including the World Bank headquarters and the collections of the late Peggy Cooper Cafritz. Thomas has received many awards from the Jamaican government for his work, including the Anthony Musgrave Medal for his national contribution to the arts. He currently lives and works in Kingston, Jamaica, and is represented exclusively by the RJD Gallery in New York.

Detail of Leonardo Benzant, *The Tongue on the Blade: Serenade for Aponte and All Those Who Have Vision*, 2017

EXHIBITION CHECKLIST

The exhibition *Coffee, Rhum, Sugar & Gold: A Postcolonial Paradox* was held at the Museum of the African Diaspora (MoAD) in San Francisco from May 8 to August 11, 2019

Firelei Báez
Compulsion to remember and repeat, 2016
Acrylic, ink, and salt on paper
93 x 52 inches
Courtesy of Gallery Wendi Norris, San Francisco

Firelei Báez
How to slip out of your body quietly, 2018
Acrylic and oil on paper
70 x 118 inches
Courtesy of the collection of Alyssa and Gregory Shannon, Houston, Texas

Firelei Báez
Love that does not choose you (Collapse the rooms and structures that depend on you to hold them), 2018
Gouache on paper
89 x 104 inches
Courtesy of the artist and Kavi Gupta, Chicago

Leonardo Benzant
The Tongue on the Blade: Serenade for Aponte and All Those Who Have Vision, 2017
Chicken wire, paper-mache, fabric, sawdust, coffee, sand, string, clay, acrylic gel medium, monofilament, and glass seed beads
75 x 39 x 9 inches
Courtesy of Claire Oliver Gallery, New York

Andrea Chung
Proverbs 12:22, 2019
Sugar, beads, rice, herbs, spices and paper, site-specific installation
81 x 74 inches
Courtesy of the artist

Adler Guerrier
Untitled (blck-Devoted to the cause and improvement), 2018
Digital color video with sound, 12:05 min.
Installation variable
Courtesy of the artist and David Castillo Gallery, Miami Beach

Adler Guerrier
Untitled (Place marked with an impulse, found to be held within the fold) iv, 2019
Ink, graphite, collage, acrylic, enamel paint, and xerography on paper
71 x 48 inches
Courtesy of the artist and David Castillo Gallery, Miami Beach

Adler Guerrier
Untitled (Presence in this place is contingent on forms; Sugarcane) I, 2019
Solvent transfer, graphite, ink, and acrylic on paper
40 x 30 x 3
Courtesy of the artist and David Castillo Gallery, Miami Beach

Adler Guerrier
Untitled (stoic derivation and decolonial), 2019
Wall painting
Dimensions variable
Courtesy of the artist and David Castillo Gallery, Miami Beach

Lucia Hierro
Aesthetics y Politics, 2019
Custom, site-specific wall installation
97 x 242 inches
Courtesy of the artist

Lucia Hierro
Embajador, 2017
Poly organza, digital print on brushed nylon
27 x 87 x 54 inches
Courtesy of the artist

Lavar Munroe
And the Dogs Went Silent: Gun Dog I, 2017
Cardboard, deconstructed junkanoo costumes, found toys, found marbles, rubber gloves, PVC pipe, found shoes, string, spray foam, spray paint, wood, lollipop, feathers, latex house paint, and polyester resin
44 x 29 x 18 inches
Courtesy of the artist and Jenkins Johnson Gallery, San Francisco and New York

Detail of Phillip Thomas,
Pimper's paradise, the Terra Nova nights edition, 2018

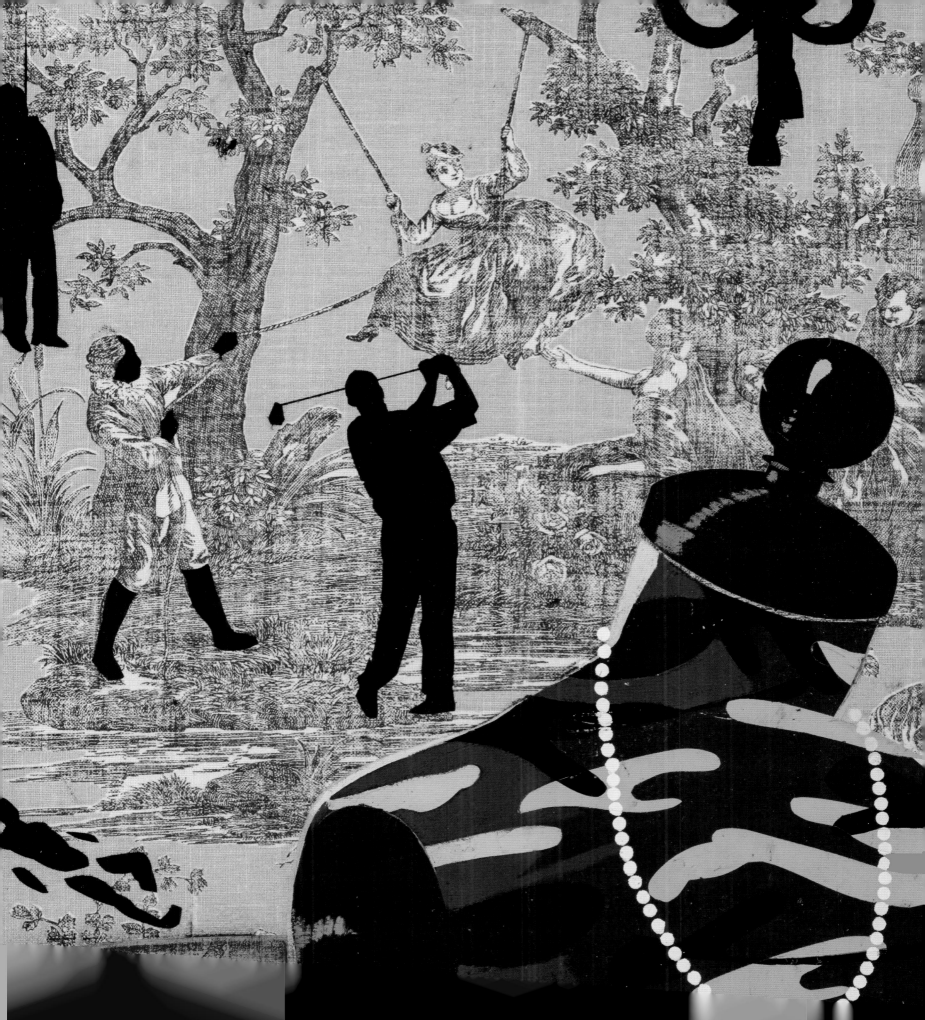

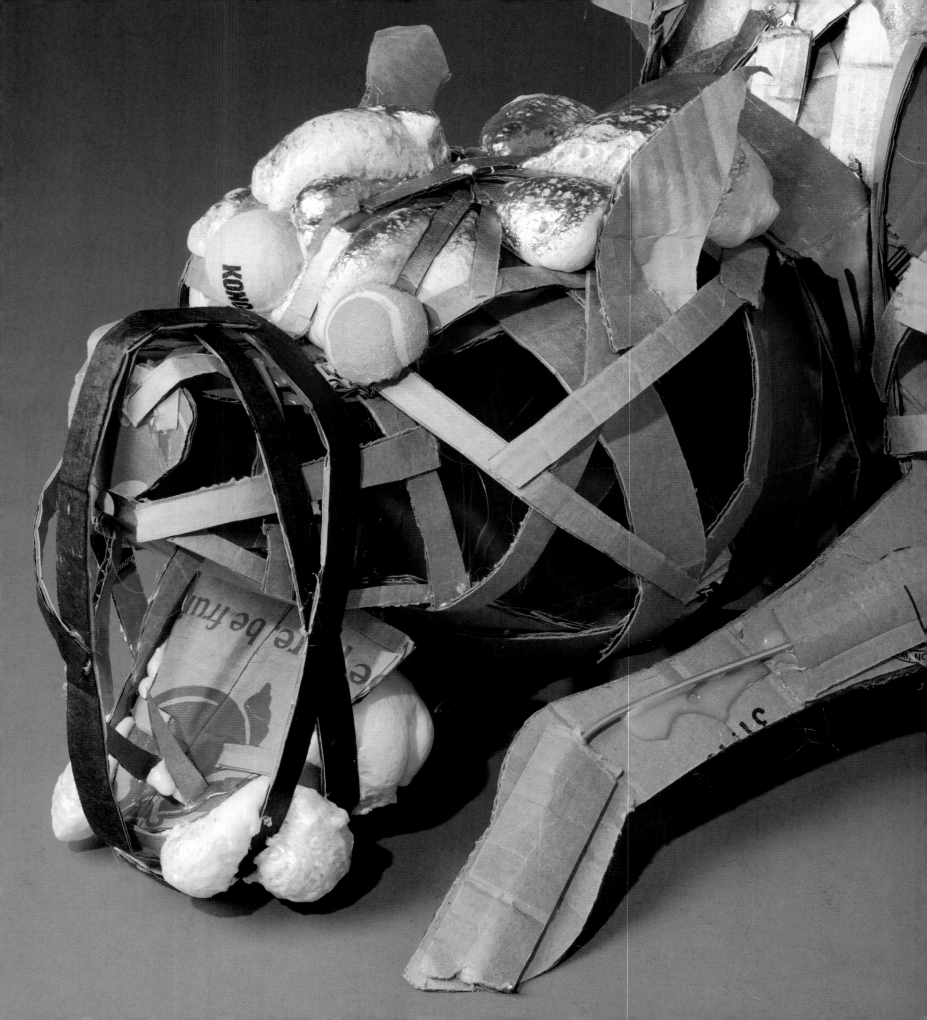

Lavar Munroe
And the Dogs Went Silent: Gun Dog 2, 2017
Cardboard, deconstructed junkanoo costumes, found toys,
found marbles, rubber gloves, PVC pipe, found shoes,
string, spray foam, spray paint, wood, lollipop, feathers,
latex house paint, and polyester resin
22 x 44 x 27 inches
Courtesy of the artist and Jenkins Johnson Gallery, San Francisco and New York

Lavar Munroe
And the Dogs Went Silent: Gun Dog 3, 2017
Cardboard, deconstructed junkanoo costumes, found toys,
found marbles, rubber gloves, PVC pipe, found shoes,
string, spray foam, spray paint, wood, lollipop, feathers,
latex house paint, and polyester resin
28 x 41 x 15 inches
Courtesy of the artist and Jenkins Johnson Gallery, San Francisco and New York

Lavar Munroe
Beast of the Night, 2018
Cardboard, tennis balls, spray foam, chain, and spray paint
22 x 55 x 32 inches
Courtesy of the artist and Jenkins Johnson Gallery, San Francisco and New York

Lavar Munroe
Caged Beast, 2018
Cardboard, tennis balls, spray foam, chain, and spray paint
14 x 41 x 22 inches
Courtesy of the artist and Jenkins Johnson Gallery, San Francisco and New York

Lavar Munroe
Church in the Wild, 2019
Mixed media on canvas
72 x 57 inches
Courtesy of the artist and Jenkins Johnson Gallery, San Francisco and New York

Lavar Munroe
Spy Boy, 2018
Acrylic and earring stud on untrimmed canvas
68 x 48 inches
Courtesy of the artist and Jenkins Johnson Gallery, San Francisco and New York

Detail of Lavar Munroe,
Beast of the Night, 2018

Angel Otero
"Slots" Sl#1 (SCA03), 2013
Fired steel and glazed porcelain
94.5 x 33.5 x 27 inches
Courtesy of the artist and Lehmann Maupin, New York, Hong Kong, and Seoul

Angel Otero
Untitled, 2013
Oil paint and oil paint skins collaged on canvas
96.5 x 72.5 x 4 inches
Courtesy of the artist and Lehmann Maupin, New York, Hong Kong, and Seoul

Angel Otero
Veranda (Sca02), 2013
Fired steel and glazed porcelain
#1: 37.5 x 21 x 23 inches; #2: 37 x 18 x 23.5 inches
Courtesy of the artist and Lehmann Maupin, New York, Hong Kong, and Seoul

Ebony G. Patterson
A View In, 2015
Mixed-media jacquard-woven tapestry with hand-cut elements
79.5 x 56 inches
Courtesy of Jenkins Johnson Collection, San Francisco

Ebony G. Patterson
A View Out, 2015
Mixed-media jacquard-woven tapestry with hand-cut elements
79 x 58 inches
Courtesy of Jenkins Johnson Collection, San Francisco

Phillip Thomas
Pimper's paradise, the Terra Nova nights edition, 2018
Mixed media on canvas
84 x 194 inches
Courtesy of the artist and RJD Gallery, Bridgehampton, New York

Didier William
"Lonbraj mwen se kouwon mwen" 1, 2019
Collage, acrylic, and wood carving on panel
63 x 49 inches
Courtesy of the artist

Didier William
"Lonbraj mwen se kouwon mwen" 2, 2019
Collage, acrylic, and wood carving on panel
63 x 49 inches
Courtesy of the artist

Didier William
"Lonbraj mwen se kouwon mwen" 3, 2019
Collage, acrylic, and wood carving on panel
63 x 49 inches
Courtesy of the artist

CONTRIBUTORS

Larry Ossei-Mensah, MOCAD's Susanne Feld Hilberry Senior Curator, is a Ghanaian-American curator and cultural critic who has organized exhibitions and programs at commercial and nonprofit spaces around the globe in addition to documenting cultural happenings featuring the most dynamic visual artists working today. Ossei-Mensah is also the cofounder of ARTNOIR, a global collective of culturalists who design multimodal experiences aimed to engage this generation's dynamic and diverse creative class. In 2017, he was the critic-in-residence at Art Omi, and in 2019, he will serve as a curatorial mentor at the VisArts in Rockville, MD.

Dexter Wimberly organizes exhibitions that explore contemporary culture, American history, economics, and power dynamics. He is the cofounder and CEO of Art World Conference. A passionate supporter of the arts, Wimberly has exhibited the work of hundreds of artists internationally. During his decade-long career, he has organized exhibitions and programs at dozens of museums and galleries, including the Contemporary Art Museum (CAM) Raleigh, the California African American Museum, the Museum of Contemporary African Diasporan Arts, 101/EXHIBIT gallery, Koki Arts gallery in Tokyo, and the Third Line gallery in Dubai.

Emily A. Kuhlmann is the Director of Exhibitions and Curatorial Affairs at the Museum of the African Diaspora. In addition to managing the evolving exhibitions program at the museum, she has curated solo exhibitions, including *A Matter of Fact: Toyin Ojih Odutola* (2016), *Todd Gray: My Life in the Bush with MJ and Iggy* (2017), and *Sadie Barnette: PHONE HOME* (2019). She received a Master of Arts in Visual and Critical Studies from California College of the Arts and continues to focus her research on performance and critical race art history.

Eddie Chambers is a professor at the University of Texas at Austin, where he teaches African Diaspora art history. His education includes a PhD in History of Art from Goldsmiths College, University of London. He has an extensive background in curating and his past exhibitions include *Frank Bowling: Bowling on Through the Century* and *Tam Joseph: This is History*. He has written extensively in such publications as *Third Text, Art Papers, and Art Monthly*, and his recent books include *Black Artists in British Art: A History Since the 1950s* and *Roots & Culture: Cultural Politics in the Making of Black Britain*.

RIGHT: Detail of Lucia Hierro, *Aesthetics y Politics*, 2019

OVERLEAF: Didier William, *"Lonbraj mwen se kouwon mwen" 3*, 2019

Library of Congress Cataloging-in-Publication Data available.

ISBN: 978-1-944903-76-3

Printed in China

10 9 8 7 6 5 4 3 2 1

Photography by Phocasso, John Wilson White

Jacket front and back cover: Details of Ebony G. Patterson, *A View In*, 2015

Jacket back flap: Angel Otero, *Veranda (Sca02)*, 2013

Case front cover: Detail of Andrea Chung, *Proverbs 12:22*, 2019

Case back cover: Detail of Firelei Báez, *Love that does not choose you (Collapse the rooms and structures that depend on you to hold them)*, 2018

The Andy Warhol Foundation for the Visual Arts

GENEROUS SUPPORT FOR PROGRAMS AND EXHIBITIONS IS PROVIDED BY
Dignity Health; Kaiser Permanente Verba Buena Community Benefit District; The City & County of San Francisco

ADDITIONAL PROGRAM SUPPORT IS PROVIDED BY MAJOR SUPPORTERS OF THE AFROPOLITAN BALL
Jill Cowan Davis & Stephen Davis; Concepción & Irwin Federman; Karen Jenkins-Johnson & Kevin D. Johnson; Beryl & James Potter; Jordan Schnitzer Family Foundation; The Allen Group LLC; Five Point; Gilead; Verizon; Pacific Gas and Electric Company; Target; Union Bank; Wells Fargo

CAMERON + COMPANY
149 Kentucky Street, Suite 7
Petaluma, CA 94952
www.cameronbooks.com